First Horse

First Horse

Basic Horse Care Illustrated

by Ruth Hapgood

Photographs by
Eleanor Schrawder

Chronicle Books San Francisco

Contents

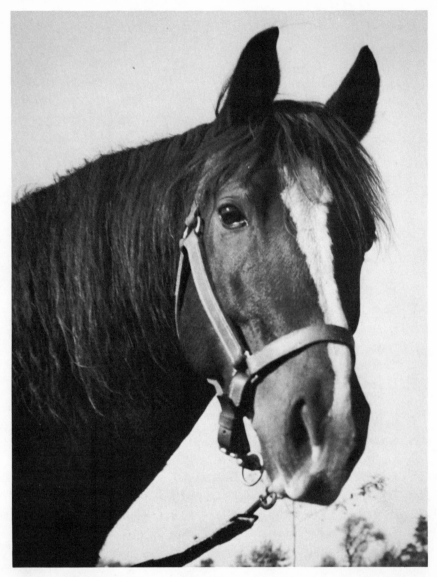

A horse with a kind face probably has a good disposition.

Foreword

When my two children were ten and fourteen, we were suddenly asked to take care of a horse whose owners were going away. A few brief instructions about what to feed him and where to get the water and we were on our own. The children had had riding lessons, but that hadn't prepared us for taking care of the creature. He laughed at our efforts to pick up his feet to clean them. He made such alarming faces to say he was hungry that we thought he must be ill. He wouldn't lead where we wanted him to go. (He wasn't very easy to ride, either.) We had to learn or else. We read all the books in the library. We pestered the life out of anybody who would answer questions. What is the frog? How hot is hot? How do you tie a horse knot? Is it all right to let him graze for hours?

This is the book we wished we had right at the beginning. We hope it will help you.

We are assuming that you already know how to ride a bit and that you're not starting out with an untrained young horse or pony. If you have never had horses and don't ride well yourself, the going will be tough, and you will need an experienced horseman to turn to. In that case you won't need this book. If you don't have a horse yet, please read Chapter 12 first, How Not to Buy the Horse You Don't Want.

But let's assume that you know one end of a horse from the other, and have bought, or are feeding and caring for, some sensible middle-aged nag, sound, friendly, and old enough not to be too ambitious.

Some of our American horses spend their lives in a barn, and go out when they're taken out. Some horses scarcely see the inside of a barn from one year's end to the other. I think there are as many different systems of horse care as there are horse owners—and if the horse is healthy and the owner isn't breaking his back caring for him, that's the way for them. So what follows is certainly not "The Way" to take care of your horse, but it's "One Way" that works. It is presented as something definite for you to start from— and you can take it from there!

This whole book is a kind of thank you to all our horse friends, particularly to Eleanor Schrawder for her encouragement and breadth of view, and to our 4-H leaders, Mrs. Kenneth Read, Mrs. Peter Helburn, Mrs. Gordon Donaldson, without whom we would never have dared to take on our first horse.

1. First Horse

There stands your first horse, newly arrived, twice as large as you expected, and with a totally baffling expression. Does he greet your good intentions with friendliness and respond when you come up to pat him? He does not. As you approach he lays back his ears, and if you try to pat his velvet nose as they do in the storybooks he will probably snatch it away.

Some famous horsemen say no horse loves his master. I don't agree with that, but I observe that by and large horses are not fond of people the way dogs are, or even cats. If after six months you have gained your horse's respect and grudging approval, you have probably worked hard for it. You will have dealt with him gently and faithfully, groomed him, fed and watered him, mucked out his stall, ridden him, and shown him who is boss. For this you

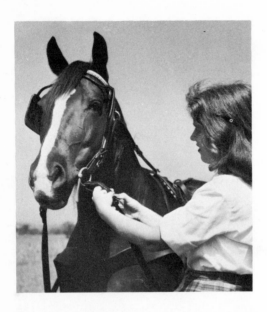

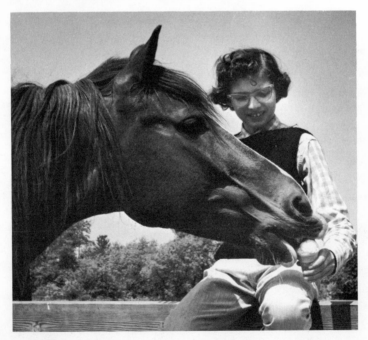

Friendly co-operation is earned—and it takes time (top).
You can share many pleasures with your horse (bottom).

will be greeted with a nicker, even though it isn't feeding time, and will be allowed to work around the stall and get through your grooming without the eye of suspicion rolling your way. You will be nuzzled, even though you rarely carry anything for him to eat. You will have earned his trust and his cheerful cooperation. Maybe then you can pat the velvet nose—though by now you know he prefers to be scratched along the neck or under the chin.

You will hear horses described as the stupidest animals going, and you will hear how they outsmarted their masters. Both things are true, which is what makes horse psychology a puzzle. Not too much goes on in their lives, so they can concentrate on what concerns them most, like picking the lock to the feed bin or getting out of the paddock. They are panicked by what seem to us the most illogical things: baby-carriages (eek!), or seeing you in a raincoat or moving in a funny way. Horses are marvelous navigators and never get lost. They have remarkable memories. Years later, even if the animal doesn't shy, you can tell by the flick of the ears that he remembers that stump made a funny noise at him once. They also never forget a person who once hurt them. Our present horse thinks all strange men are vets, and becomes balky at once. If the vet is coming, we have to catch the horse before he arrives.

Fortunately, since you can't force an animal that size to mind you, a horse is basically tolerant of people. He doesn't want to please the way a dog does, but he will do things the easy way, which means he will do what you want (within reason) to save trouble. With that good memory, you can teach him a lot—gradually—he has a short attention span and gets bored with lessons. If you say you are tougher than he is, he will believe you, and a good thing too at ten times your fighting weight. He's always hungry, so a handful of grain will work as a bribe (not as a habit, but in an emergency). And, praise be, he can only think of one thing at a time. He's distractible like a small child, so you can get his mind off some mischief by giving him something else to think about.

He's a big sensitive creature with something going on in his

head all the time. He has his grumpy days and his gay days just like people. I believe that horses commune with other horses and other animals, silently, saying quite a lot. I have a notion that you can commune with him too, if you just go easy with him, and sense his feelings and let him sense yours.

In brand new surroundings, your brand new horse may take a few days to settle down and feel at home. He may be nervous and edgy, even to the point of not finishing his supper. Handle him on the cautious side until he gets used to you, and don't assume he will take kindly to giving rides to all the kids in the neighborhood on the very first day he arrives.

2. Food and Water

He's explored his new barn and his paddock and been patted and admired by everybody. Pretty soon he's going to give that horse yawn that says, "What's for supper?"

What are you going to feed him?

With any luck you're going to feed him exactly what he's been having, and maybe you even bought a week's feed and hay with him. It's worth taking trouble to ease over onto any new food, because what is just a stomach ache to us is quite serious for a horse—it's called colic, and he can die of it, though modern treatment is much better than it used to be.

Horses came into being in the Sea of Grass in Asia. Their insides are set up to deal with an endless amount of green grass, nibbled whenever the spirit moves them day or night. A modern horse

turned out to pasture does the same thing; he eats when he feels like it, plays when he feels like it, and keeps himself looking fat and sassy, the intake nicely balanced with the outgo.

If you can manage to pasture your horse or pony, you are handling him in the most natural way, and you will save yourself a lot of the complications described in the following pages. However, most of our horses are not so lucky. We don't have lovely green fields for them to browse in, or they're too busy earning their keep to eat enough grass. These horses live on hay and grain.

"Grain" in this case means whatever form of more concentrated feed suits your ideas and the horse's appetite, perhaps oats, crushed oats, corn, barley, or various forms of mixed feed. Your grain merchant is likely to have some standardized mixtures, such as "sweet feed," which has oats, corn, and other grains, mixed with molasses; or "pellets" which come in peanut-sized pieces, a mixture of hay and grains. These latter standard mixtures are often called complete feeds, and so they are nutritionally, but in practice one usually finds it better to feed some hay as well.

The hay contains the roughage the horse needs, and some of the proteins and carbohydrates he needs too. But it takes time to eat and room to digest, so the more of your work you are asking him to do, the more grain you will feed him, perhaps even cutting down a bit on the hay.

A horse whose rider is in school is probably only doing what the feeding tables call "light work." A small 600-pound pony might get 9 pounds of hay a day plus 2 quarts of sweet feed, although many ponies get no grain at all. In fact, one of the convenient things about small ponies is that they can maintain themselves on small pastures and so you can turn them "out to grass" all summer and most of the winter too, even in suburbia's restricted spaces.

A large pony or small horse might eat 12 pounds of hay plus 4 quarts of feed; a 16-hand, 1000-pound horse, 15 pounds of hay plus 5 or more quarts of feed. Any prepared horse feed you buy will have suggested feeding tables, which will help if you really can't find out what the horse was eating before, but horses vary so much one from another in the amount they eat, some being

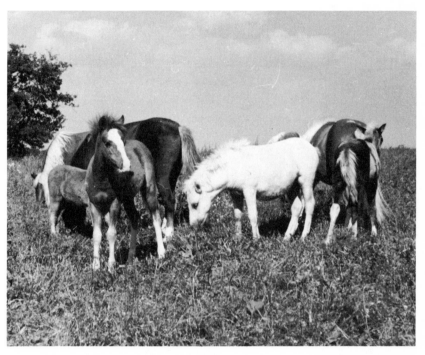

Mares and foals feed in the age-old way.

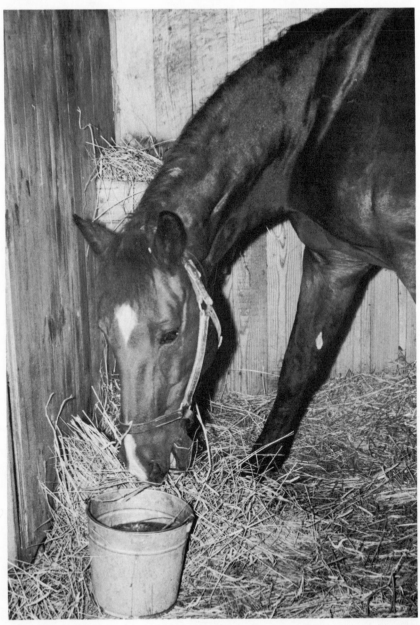

Avoid this: hay eaten off the floor may contain worm eggs and a loose bucket is an accident waiting for a chance to happen.

"easy keepers" and some very definitely the opposite, that you really can't say offhand what a particular horse will need.

Just remember that the hay (or grass) is the basic food, and the more work, the more grain is needed.

These amounts are based on a mature horse, who's not growing but just maintaining himself. Foals and mares who are nursing young ones need food and supplements on quite a different system.

Most horses have to put up with two meals a day, even though frequent small meals suit their system better. If there's someone home all day, some hay at noon will be appreciated.

Just like a dog or cat, a horse objects to being interfered with at mealtimes, but where a dog might snarl, a horse may kick, or crowd you against the wall. Politeness pays.

Avoid working your horse hard just after he has eaten. He should have time to digest before doing something strenuous. If you know he is going to have to exercise hard right after his mealtime, don't give him his full amount, but nearer one third of his grain and only half his hay. Or skip the meal entirely. (This may land you with an indignant horse whose only idea is to return to his feed bucket, so try to schedule more smoothly.)

Make changes slowly If you can't find out what he has been eating, perhaps the safest thing the first day is just hay, and, after that, hay and pelletized hay, and start slowly with the pellets to make sure they agree with him.

If he hasn't been getting any grain or concentrated food at all, start slowly, a quart or two per meal for a horse, a handful or two for a pony, several days before raising the amount. If you want to feed him more than he's been getting, give him an extra quarter of what he had, stay at that level a couple of days, then raise him another quarter. That will probably be plenty, unless he's awfully thin or working quite hard.

If he's been getting a crushed oats and horse feed mixture, and you want to calm him down (because oats tend to make him frisky) and plan to switch to pellets instead (this is mostly hay and not so full of energy), ease over to the pellets during four or five days,

a quarter of his grain being the new feed, then a half, then three quarters, etc.

The same caution holds true for turning the horse out to pasture when he's been on dry hay right along. Too much fresh green grass may make him sick. Begin with fifteen minutes of grass the first day, then a few half-hour days, and work up slowly to a full day, after which you can turn him out OK day and night. (If he breaks out of his paddock and stuffs on greenery, especially something other than grass—a stand of corn or oats, for instance—ask the vet what to do.)

Even changing hay should be done with care. Alfalfa is a lot richer than timothy, for instance, and both are sold for horses. Do the quarter, half, three-quarters trick with the new and the old hay.

People in different parts of the country use what they have, and the horses get along fine. In the west they feed more alfalfa hay, in the east more timothy. In the south and midwest the horses get a lot of corn, which makes them fat and glossy.

Is the feed good? Some sensible horses refuse to eat spoiled grain or moldly hay, but it still pays to be careful.

About the only thing you have to watch out for with pellets is that they can get moldy if they get damp. If in doubt, throw it out, and I warn you, horses always know where you throw it if it's in the same county, so bury it or get it off the place.

Sweet feed can ferment in the summer time. Get used to the good smell, and get in the habit of having a whiff when you dish it up. If it gets a cellar-like or mushroomy or beery smell, don't feed it!

Crushed oats are fine if not too dusty.

If you buy feed for only a few weeks at a time, you're less likely to have it spoil.

Hay should smell like the barn of your childhood, a fresh summery smell. The best hay is still somewhat green. Don't buy it if it's a tired old November brown. Curing hay is still an art, and perfection is hard to come by. Some golden hay is good, but some

has been rained on and lost a lot of its nutriment. The outside of the bale turns golden when it's exposed to sunlight—it's the inside you want to go by.

Shake the hay out when you give it to the horse, to get rid of any dust, and make sure you find any bits of string or brambles or whatnot before he does. If it's very dusty, wet it down thoroughly, otherwise it may give him a cough. Best way is to dunk the whole thing in a tub (not so easy in February so it's better to have good hay if you can).

If it smells moldy or queer, or you see white mold on it, don't feed it! A solid wad of hay among the looser stuff is likely to be moldy.

You will notice that by and large the best horse people have the best hay. Come fall, they have a barn stuffed with tons of some reliable farmer's early-cut first or second cutting (more nutritious). They know how the farmer fertilizes his fields and how often he plows them up and reseeds. They know the percentage of timothy and clover, or maybe alfalfa in the hay. And they have enough to see them through haying time the following summer.

The rest of us, who don't have room to store a year's supply of hay, will try to buy in smaller amounts from a reliable farmer too. Maybe the grain store will have good hay and maybe it won't. In late spring, if it was a poor year last year, a lot of us will end up feeding just pellets (a complete feed, nutritionally anyway) because the only remaining hay would starve a goat. And lacking his usual roughage, the horse will start eating trees, and fence rails, and even the barn. So try to look ahead.

Newly baled hay may not have been completely cured when it was baled. It's still going through some chemical changes, and is not good for horses until those changes are finished. A safe rule is not to feed hay unless it's been baled six weeks.

Avoid bargain hay. The best hay costs little if any more.

One-a-day for horses? Most complete horse feeds say they have all the vitamins and minerals a mature horse needs, and some vets agree, while others swear by supplements. Up to you. Myself, I

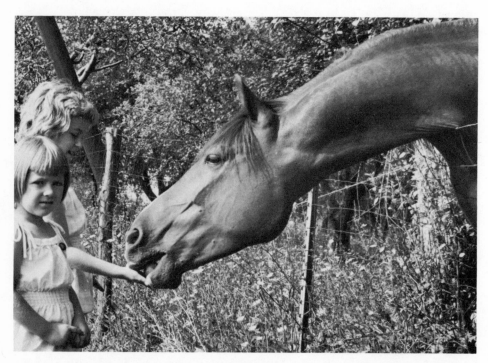

An apple (in quarters) or carrot (in pieces) is the best treat.

give a vitamin-mineral supplement extra, on the theory that the extra margin may be helpful. Follow directions and don't overdose.

Whatever you do, provide extra salt. A cake for him to lick is a handy way to do it. He will take what he needs, and you will see that that is quite a bit.

Timing Try to feed at the same time every day. If by chance you're late and he's ravenous, give the hay first so he doesn't gulp down the grain unchewed. (A lot of people feed the hay first on this account anyway.)

Poisons and poisonous plants Beware of grass clippings. They ferment (rather the way hay cures) and can make a horse sick. About the only safe way to feed a horse cut grass it to cut a handful, feed it to him at once, see him eat it all up, and then cut another, which doesn't get your grass mowed very fast.

Furthermore, beware of letting the horse nibble on a lawn that has been sprayed with weed killer, or along a roadside that has been sprayed with brush killer.

If you want to fertilize his paddock in order to grow grass there, don't do it while he's in occupancy. Even the fertilizer is bad for him.

It's nice to find him a green place to graze, and you may want to borrow or rent some grazing for him. But if fields have been let go, poisonous weeds may have come up. After our first horse was sold and his old paddock was empty for a year, the greenest thing that came up in it was bracken, a fern which often appears in old pastures, and this is poisonous to horses.

Turned out in a lovely green pasture, horses will eat the good green grass and ignore unhealthy weeds or shrubs. It's when the pasture is nibbled bare that they are likely to sample other things; for instance, in that paddock where the bracken was about the only thing to chew on.

If your horse has been starved for greenery, he may not stop to discriminate between good and bad, so give a feed of hay before you turn him out.

Fortunately, in general a horse has to eat a good deal of most

poisonous plants before they will make him sick. A few bites of bracken or wild cherry are usually nothing to get excited about. But if he goes on nibbling for a few hours on something poisonous, it will probably end by making him sick. One exception to this seems to be oleander (*Nerium oleander*) which many people have as an ornamental shrub, particularly in the southern and western U.S. The horse is not likely to want to browse on the shrub, but if oleander leaves get into lawn clippings or into hay, even a few can do him harm.

In fields the most common things to avoid are bracken (*Pteridium aquilinum*), and the horsetails or scouring rushes (especially *Equisetum arvense* and *Equisetum palustre*). In the west and southwest add locoweeds and pointvetches (*Astragalus* and *Oxytropis* species) to this list.

Among trees, the chief one to avoid is the wild black cherry (*Prunus serotina*), which is most dangerous when leaves are wilting, but can be harmful anytime. Also avoid its relations the choke cherry (*Prunus virginiana*), southern mock-orange (*Prunus caroliniana*), and pin cherry (*Prunus pensylvanica*). Other trees you don't want your horse to browse on are the black locust (*Robinia pseudoacacia*), oaks, and buckeyes or horsechestnuts.

The most dangerous shrub grown around houses is the oleander mentioned above. Also dangerous are yews, particularly the English yew (*Taxus baccata*). Even hedge clippings of common box (*Buxus sempervirens*) or common privet (*Ligustrum vulgare*) should be avoided.

Some field crops or ground covers make bad eating for horses, among them:

Vetchlings (*Lathyrus*), especially the caley pea (*Lathyrus hirsutus*)

Field or austrian pea (*Pisum sativum,* var. *arvense*)

Crimson clover (*Trifolium incarnatum*)

Red clover (*Trifolium pratense*): this may also be harmful if too high a proportion of second cutting or late season red clover occurs in hay

Alsike clover (*Trifolium hybridum*)

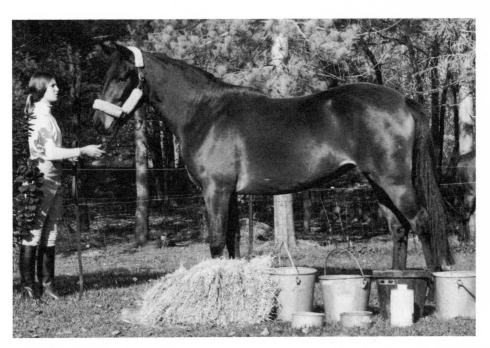

This horse will eat in one day some 15 pounds of hay, at least four buckets of water, four quarts of pellets, and a scoop of vitamin-mineral supplement.

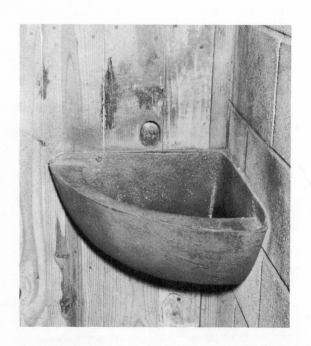

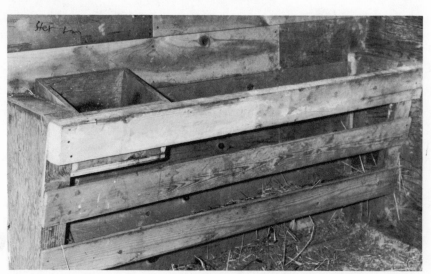

An indestructible metal food trough may be needed if your horse gnaws on a wooden manger (top). A convenient manger for hay, with a shallow box at left for grain made of solid smooth construction (bottom).

Some kinds of *Sorghum*, Johnson grass or sudan grass.

If you know that a plant is poisonous to people, it's likely to be harmful to horses and other domestic animals as well. For instance, these well-known plants are highly toxic for horses: *Datura* (Jamestown or Jimson Weed, thorn apple), *Cicuta* (water hemlock—*Cicuta maculata* has the suggestive names of Spotted Cowbane and Beaver Poison), and *Conium maculatum* (poison hemlock, the kind the Ancient Greeks put people to death with).

Fortunately the horse doesn't need to look these up in a book—he just avoids them all, given half a chance. You, however, might check with your vet or Agricultural Extension Service on the poisonous plants in your area.

Overeating One thing the domestic horse has no sense about is overstuffing. If he gets his head in the feed bin he can eat enough to kill himself. If he does start stuffing and you catch him when he has eaten only about a double meal, give him a very little water and no supper and walk him a couple of hours and he will probably be OK. But if you think he got more than that, withhold all water and call the vet.

How to feed To begin with you will probably toss the hay on the ground and let him eat from there. By and by, you will realize that manure is also on the ground, and manure has worm eggs in it, and the horse is reinfecting himself with worms, so you will build a hay box. This construction is sturdy, big enough to hold a good-sized ration of hay. It has no bottom, so there's no drainage problem. And it keeps hay and manure separate.

In the barn the hay can go in a manger. Opinion is divided about hay nets, but if you use one be sure to tie it high so he won't catch a foot in the ropes. Remember it will hang lower when it is empty.

As for the grain, it's easy to feed this from a bucket. Keep the bucket clean, and fasten it so he won't clumsily fall over it or hurt himself on it somehow.

Water Every bit as important as food is the water. In fact, the

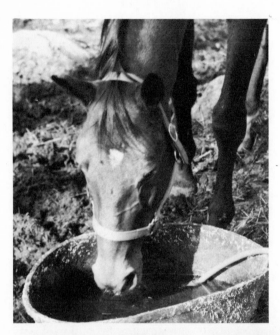

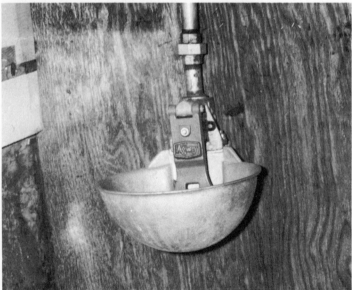

This large rubber tub is safe for horses and unlikely to be tipped over (top). An automatic water fountain is convenient, but make sure it can be turned off when necessary (bottom).

saying is that water is your cheapest feed. He should always have water to drink, clean water in a clean container. If he's run dry, be sure to give him water again before you feed. In general, he can suit himself about when and how much to drink. But if he comes back hot and thirsty from a ride, it's better to give him just a few swallows at a time over a period of an hour or more until he has stopped sweating and is cool.

Try to arrange so that you hang up the buckets for his feed and water. A snap hook will do, fixed to a ring (better than a big hook or, perish forbid, a nail) in the wall or post. There are fancier arrangements you can set a bucket in so the horse won't overturn it. But the main idea is to keep the buckets out from underfoot so he won't hurt himself on them—he can really wreck his foot by getting it caught the wrong way between the bucket and the handle.

Galvanized pails will do if you're starting on a shoestring, or live far enough south so the pails don't freeze in winter. Otherwise you want a couple of nice rubber buckets because they will last— weird things happen to metal pails when the water freezes in them and the blizzards bury them. Rubber is also safer.

Try and have a source of water handy to the stable, a hose or pipe. A pipe will have to be protected from freezing. So will the hose in bad weather, but it's easier to take up and put indoors. Warm water is a blessing if you can be luxurious—otherwise you will be carrying a lot of hot teakettles in February.

Is he fat enough, or too fat? A horse with big round ribs may look fat, and a horse with big rangy hipbones may look thin, and a pony in his winter coat looks like a featherbed on legs. How do you tell?

The best place to check is the ribs. Can you feel the separate ribs? If so, the animal is on the thin side. Can you feel that the ribs are there but not for sure which is which? You're probably about right.

Is there a big hollow between the point of the hip and the

ribs? Either he's thin or short on water or both. Old brood mares will have a bigger hollow than a trim young horse.

I like my horses to have a layer of fat to see them through the winter, but it's a good idea to keep track of what is going on under that winter coat, because when he sheds it you may find that he billows when he walks.

A horse that is out to grass, or getting mostly hay and little concentrated feed and not much work may develop a "hay belly," which looks like the "before" picture for tummy support advertisement. If his belly is much fatter than the rest of him, you should consider reducing the hay and giving more concentrate and upping the exercise.

Condition Stand off and look at your horse. Does his coat have a gleam on it, a bloom, even before you groom him? You must be doing something right.

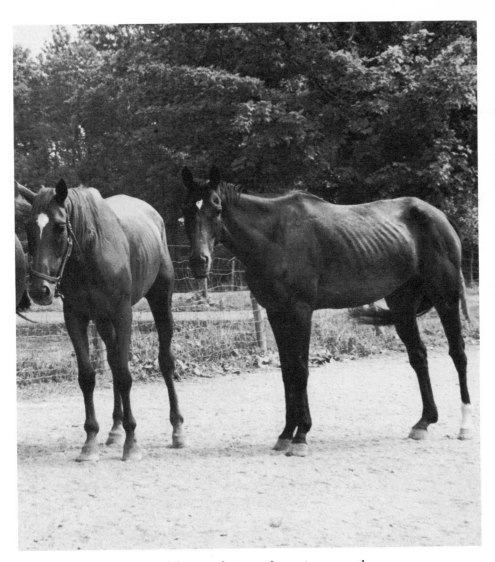

This is a good example of horses that aren't getting enough to eat—because of inadequate food, worms, or bad teeth.

Learn to recognize when your horse is protesting.

3. What's He Saying?

Right at first, it's very hard to tell what a horse's expression means.

Ears pricked, a look of alert and friendly interest.

Ears half back, suspicion and concern.

Ears moving back one or both, "I hear you but haven't decided if I approve."

Ears skinned back, "Watch it!" It depends on the horse what is coming, a kick, bite, rear, or strike with the forefeet, or a charge forward—but the situation is explosive. Take steps.

What kind of steps?

1. You can scram, quick! But reassert your control as soon as you can plan how to do it.

2. If he's tied up already, as when you're grooming, you can stop him with a stern word and a smack on the shoulder and a

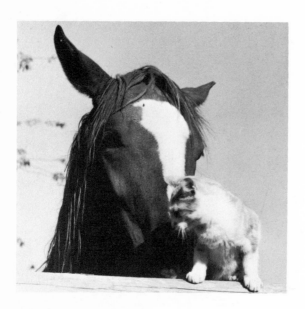

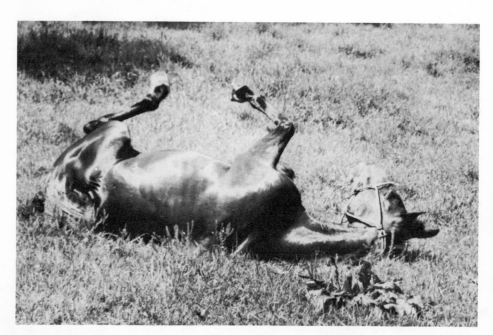

*Friendly but cautious conversation (top). A luxurious roll after
a long ride is much appreciated (bottom).*

jerk on his nose from the halter. "Hey, you! Mind your manners!" we could say to a horse whose hind feet got restless and whose ears went flat back when we were working at the rear end. It helps in that sort of situation to have another person at the front end to keep his attention and report on the ears.

3. If you have hold of him by reins or lead rope, you have some control over nose or mouth, so use it quickly and demand his attention. He can't at the same time pay attention to you and go on with his plan for misbehaving.

4. He's loose and angry. Some horses who charge at you are bluffing. Some charge and bite. Unless you're carrying a stick and are prepared to use it, retreat fast, and fight the battle when you can win it.

5. It might just be that he was upset by a wasp and not thinking about you.

How hot is hot? We pestered the life out of people trying to find out the answer to this one. The book says, you have to bring your horse back cool from a ride, or walk him afterwards until he's cool. It's simple when you know. The place to tell is between his forelegs. If that feels hot to your hand, then he's hot and must be walked to cool down before you leave him be. If he's damp and sweaty there, the rest of him, particularly underneath, will be wet too, and you will have to take steps to get him dry except in real summer weather (more about this in Chapter 9). When he's cool, his chest will feel "room temperature" like the rest of him.

Is he cold? Run your fingers deep into the fur of his winter coat, and if you feel a nice warm stove glowing under there you can be reassured even at zero out of doors. If down by the skin is cool or cold he might appreciate a blanket or shelter or both, especially if there's a wind. If he's feeling the cold he will shiver, and the shivering helps to warm him actually, though that's the time when I like to get him under cover.

Is he thirsty? Assume so if the bucket is nearly empty. Our first

horse used to kick his water bucket all around the paddock if he wanted more. (That was before we learned to fasten the bucket safely.) Our second used to put his hoof in and stamp, making a glorious noise in the empty tin. Our third sticks his nose in the empty bucket when he sees us coming and then whinnies. It's worth trying hard to give him more than enough until you have some idea of what he needs—and clean water in a clean bucket, please.

Is he hungry? Horses are always hungry, and if he thinks he can persuade you he's starving by making faces or pawing and tossing his head up and down he will certainly do so.

Is he well? If you will practice being observant about your horse's habits you will soon detect if he's ever out of sorts. His head is lower, his coat not so healthy looking and shiny. You will be able to tell if he's lying down and breathing easy for a nice rest or sunbathe, or if he's lying down, sweating and breathing heavily and feeling tense because of a stomach ache. You can tell if he rolls happily and shakes himself like a dog when he gets up, or if he rolls because he is in pain. You can tell if his expression is sad, anxious, and drawn, or if he's his usual cheerful self. Just like people, if he's interested in what is going on around him, and cleans up his supper, he's probably A-OK.

4. Grooming and Daily Care

This is one of the very best ways to make friends with your new animal. Horses usually like to be groomed, and they're nicely under control so you have no problems, and you get on a very personal footing very quickly.

This grooming routine is a daily thing—with some exceptions. If your horse lives in a barn, he probably needs the cleaning-up and stimulation of daily grooming. If he's turned out to pasture, he rolls and cleans himself. Also he finds clean places to sleep and to stand, and thus doesn't get dirty the way a barn horse does. At the times of year that you are riding every day, you probably want to groom him every day too.

Step 1, cross tie him. This means tie him by two ropes between two conveniently spaced posts in stall or barn, or even between

two trees. These should be near enough together so that he can't turn around after you have tied him up. The ropes go from the lower side rings on his halter, or from under his chin, to a point a little higher than his head, and they're loose enough to let him move his head but don't sag down far enough for him to get a leg over one.

If you tie him up by only one rope, or no rope, he will soon forget his manners and start shifting around when he should be standing still, and then you will have to discipline him when it really was your fault.

Step 2, the curry comb. Real horsemen use the curry comb in one hand and the stiff brush in the other hand, one brushes away what the other scrapes loose. None of us ever had that much muscle available and the other way works all right. Rub the curry comb in circles all over the well-padded part of him, neck, body, and upper legs. Easy over any bony places, and not too rough with a horse with fine fur and thin skin. (We like the kind of curry comb with rubber or plastic teeth rather than some of those sharp metal ones you see for sale.)

Step 3, the stiff brush. Brush out mane and forelock, then along the neck, down the front, between the front legs and carefully under those folds where the leg hitches on. Back along the body. Go with the hair, so you have to brush uphill in front of the hind leg. This is a ticklish spot, be firm but gentle. Down the legs all the way to the ground, easy on the bony parts. Brush carefully under the corner by the back of the hoof. Brush the tail (some people say comb only and some say brush only—it's a matter of pulling out the fewest hairs). Stand beside the back leg and pull the tail to you instead of standing right behind the horse. Of course your animal is too gentle ever to think of kicking, but get in the habit of working safely and one time it will pay off. If you stand against the hind leg it's very hard to be severely kicked; to the side you are just about safe, and even around toward the back you will be shoved by the hock before you will be whammed by the hoof.

Then do the other side starting at the ears again. Don't miss between the ears and the place where the halter and bridle go

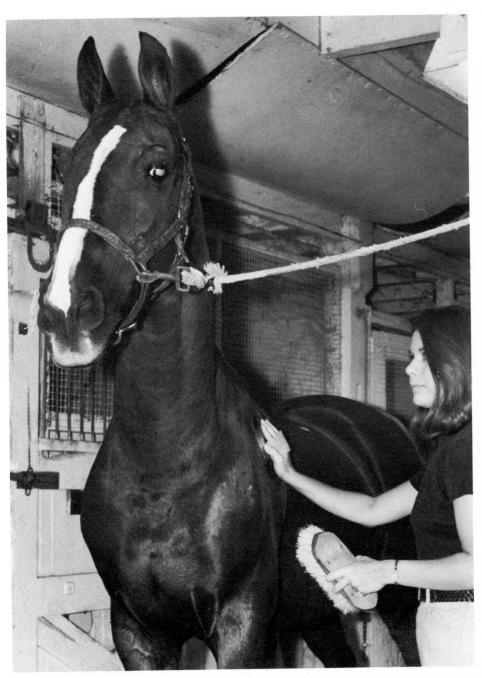

When grooming, cross-tie your horse for safety. Brush with the left hand to remove dirt loosened by curry comb.

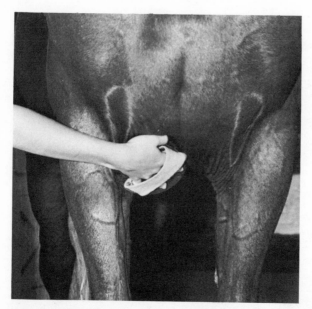

Curry gently here.

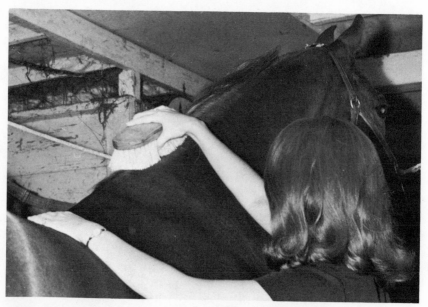

Brush thoroughly under the mane.

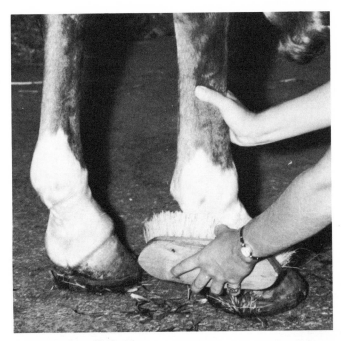

Don't forget the heels.

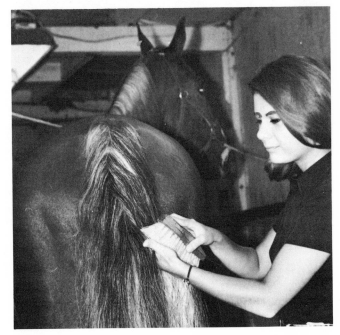

Separate the strands of tail to get to the skin.

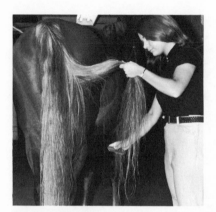

A strand at a time, work up from the end.

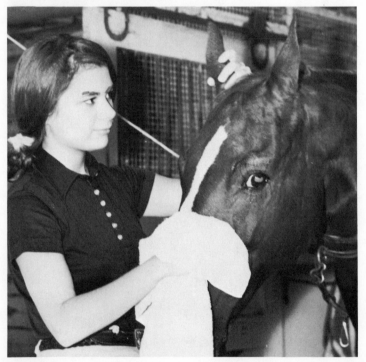

Then polish the coat with a clean terry cloth.

over his head. Clean under the mane and in the roots of the mane.

Step 4, the soft brush. This does the face, carefully and slowly. A lot of horses are headshy, and who can blame them? Who would you trust to brush your face? Then the whole body again, both sides. You can use the curry comb to clean the dirt from the soft brush every few strokes.

Step 5. If you really want to put a shine on him, end off by rubbing a body rag all over, terry or some other rough soft cloth. (Clean, please. I'm sure you will keep all these things as clean as your own comb and brush once you think of it.)

Step 6, the mane comb. This metal comb will help with mane or tail snarls. Start at the bottom of the snarl, not at the top. Fingers may be better than a comb. Horses don't usually mind having their hair pulled as much as little girls do, but you don't want to thin out a nice mane or tail carelessly.

Step 7, the face rag. Wipe off his face, particularly around the eyes and nose. Use water if you need to but try to avoid soap. Wash out the nostrils if they're dirty.

Step 8, a different clean rag to clean under his tail if it needs it. And see that the underside of the tail is clean too. Some horses seem to be always tidy there, and some need to be washed in clean warm water, or a very mild soap occasionally. A little vaseline will help if there's an irritation. We use baby oil or baby lotion to wash with in very cold weather when it seems too brutal to use water.

Don't be embarrassed if this is the first time you ever washed a horse's bottom. He's used to it. The same goes for his sheath (for male horses). The outside may need a wash once in a while because gnats have been biting it, or the weather's hot and he has prickly heat. Some horses may need to have you wash the penis once or twice a year, so try to seize a moment when it's extended; just warm water is fine unless you think the situation calls for soap, in which case use only mildest Ivory or castile and try to rinse as well as you can. He will shed the outermost skin off his penis as a way of cleaning it, so don't be alarmed if he does.

A mare (female) probably needs no special washing, though

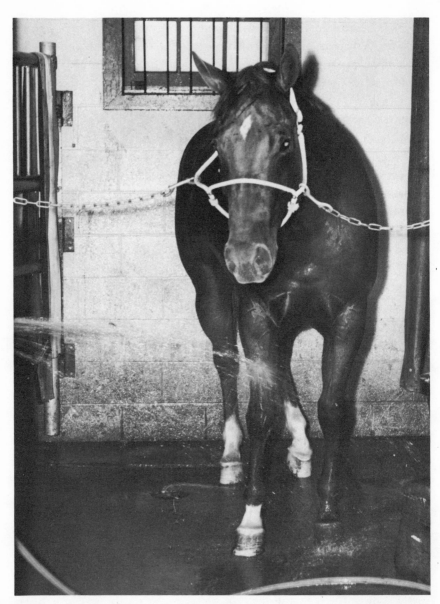

A shower bath is okay in warm weather.

a few will stain their back legs a little when they're in heat and you want to rinse that off. Sometimes dirt gets around and behind the udder where it's overlooked. Go after that with a damp cloth.

Step 9. Clean the feet with a hoof pick, not too sharp a one. Start at the left front foot. Face the rear. Run your hand down the back of his leg to the ankle and give a little tug. If he's cooperative he will pick the foot up. Our first horse stood firmly on all four feet for three days and laughed at us. We finally went back to our riding instructor and begged for a grooming lesson. Armed with that know-how we advanced upon the horse and nearly fell over when he handed us his foot.

If he doesn't cooperate for a hint, stand up, lean against the shoulder until he shifts his weight to the other three feet, run your hand down the back of the leg and tug again. If no result, he's playing with you. Smack him, tell him he's bad, and demand the foot. If you have to insist, you can pinch the tendon at the back of the leg, low down—but then teach him to be more cooperative.

Rest the foot on your knee if you have trouble holding it up. With the hoof pick, clean out any manure in the foot. If it's packed solid, start along the shoe (if he's shod) or at least with a downward stroke (toward the toe of the hoof) until you can see what you're doing. The hardest and most necessary part to do is the deep cleft on each side of the frog (that cushion in the middle). Be firm. You won't hurt him. Be thorough. Old manure in the foot, or standing in dirty places, sometimes leads to a hoof rot called thrush.

While you're there, check that the shoe is on properly. The frog sometimes sheds its rather thick skin in large shreds; this is OK.

Do the feet in order, left side and then right side. Face to the rear for the hind feet too. If you pull the hind foot rearwards instead of leaving it folded under him, he can't snatch it back so easily, but some horses can't or won't let you do this. Hold a front foot high if he's trying to take it away from you. (If he does get the foot free, he's likely to stamp it down, so it helps if your toes are not underneath.)

As often as need be, particularly in dry hot weather, you will

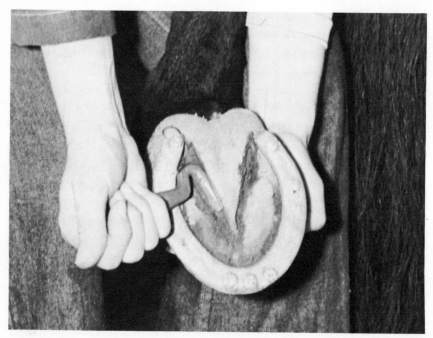

Keep feet clean with a hoof pick, several times a day if necessary.

put some hoof dressing or lanolin on the outside of his hoofs. A little lanolin rubbed into the hoof along the hair line will help the hoof to grow and keep it from getting dry and tending to crack. Various preparations are sold for this wherever there are horse supplies; these are often applied to the whole outside of the hoof, but not the underneath.

That's the end of the daily grooming routine. You have been all over him. You know how he's feeling that day. You have found any nicks or bites or scratches, or bruises or bumps, or hot places that warn of a trouble spot. You have seen if there's any skin trouble starting, like ringworm, or any ticks to be got rid of. You have made him feel good—they used to say a good grooming was as good as a feeding.

(For saddling up, see the next chapter.)

Now for the daily barn routine. Scrub any buckets or anything that needs it. Check the stall for anything broken or jagged and mend it promptly. Find the wet place (if any) in the bedding on the floor of the stall. You may have to rake off the top layer to find it. Remove the wet bedding. Remove any manure. Add a little lime on the ground if the stall is smelly. Make the bed smooth again and add new bedding as needed. If you can really keep ahead of the wet places every day, your stall will never smell strong. (Some unhelpful horses don't seem to feel right in a clean stall and promptly urinate in the middle of it, but some appreciate a clean dry place, and if they're left to go in and out freely will keep it clean for weeks.) This governs how often you have to give the thing a thorough clean-out.

What do you use for bedding? Wood shavings are good and can be bought in bales, as can crushed sugar cane, and also peat moss. The texture of peat moss is fine but it's hard to find the dirty spots. Straw is also used but is not as absorbent. Never use old hay as the horse may nibble it, and it might be spoiled or too dusty.

In suburbia, where a lot of horses live nowadays, getting rid of manure can be an awkward problem—but not getting rid of it can be worse! Near neighbors, particularly downwind from your

paddock, can cause you a lot of trouble with the Board of Health. So before your horse moves in, check the regulations in your community. You may not be allowed to accumulate manure at all, or you may have to keep it in an enclosed place with a roof and four walls. Try and set up relations with a friendly farmer who has a use for the stuff and will take it away periodically, or let you dump it regularly. What you have to get rid of is called "stable cleanings," and consists of wood shavings or sugar cane mixed with manure. These make reasonable mulch but are very acid.

Manure only breeds flies while it's fresh and moist. You can spray the new droppings with a fly spray if you're bothered by flies in summer. The old stuff is relatively odorless and harmless, except as a source of horse worms.

5. To Bridle, Saddle, and Harness

There's nothing more discouraging to a beginner than to watch a horse person bridle and saddle a horse with no trouble at all and then tackle it himself and have no luck. But it can be done. First catch your horse and groom him as described in the previous chapter. Take special care on the points necessary for his comfort: a thoroughly clean back and belly and clean feet.

Next put on the saddle. Whether you ride English or Western, the basic procedure is still the same. Stand at the left of the horse. Lower that saddle as gently as you can onto his back, a bit forward of where it should be, and slide it back to where it belongs, thus smoothing the hair as you go. You don't slide it the other way because that would rumple the hair and would be uncomfortable or worse.

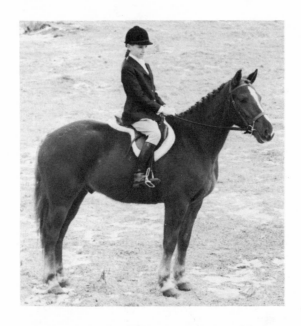

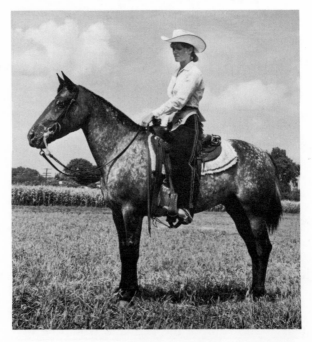

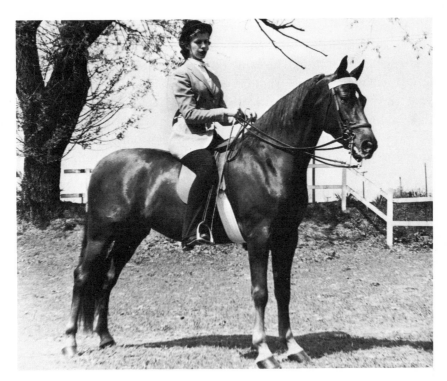

(*Above*)

English, Saddle Seat. The horse wears a double bridle with both curb and snaffle bits. The straight saddle allows the rider to take the correct position for this style of riding. The rider wears a dark derby, a full-cut coat, and long saddle seat breeches over jodhpur boots which come above the ankle.

(*Upper left*)

English Hunt Seat. The horse is wearing an English bridle with a mild snaffle bit, a single braided rein, a cavesson over his nose. The saddle is a forward seat saddle with knee rolls. Rider wears a hard hat in black velveteen, a black coat, tan breeches, and high boots.

(*lower left*)

This Appaloosa wears a one-eared buckstitched headstall and reins, a western curb bit, and no noseband. The saddle is a double-rigged stock saddle. The rider wears a western straw hat, neat western shirt, buckstitched shotgun chaps and regulation cowboy boots.

When you fasten the girth or cinch under his stomach, about any horse worth his salt will blow himself up so his stomach is real big and he thinks he's fooled you and he will have a nice loose girth when he lets go of his breath. Never mind. Finish getting your rig in order and then lead him a few steps so he will forget to keep himself blown up. Then finish tightening the girth. It should be hard to get your fingers under it at the bottom, but not so hard at the sides. You don't have to fasten the saddle on tight enough to choke him.

With an English saddle, you start with the stirrups up (slide them up the back stirrup leather and tuck the long leather part through the stirrup). The girth is up over the saddle from the right. The saddle pad is hitched to, or held to, the saddle so your hands maintain a ridge for his backbone, especially at front.

Settle this rig onto his back. Go around to the right side, check to see that the saddle pad is smooth on the far side. While you are there, get the girth off the top of the saddle and let it hang down (this saves banging his right leg if you drop it down while standing on the left), and let down the right stirrup. Come back to the left side, reach under his belly, bring the girth smoothly under, and fasten it about as tight as it will go just using your fingers. Let down the left stirrup. Check to see that all the running gear is OK. After you have put on the bridle, tighten the girth again and you are ready to mount.

This is the standard English rig at its simplest. Ponies often have extra attachments to their saddles, such as a tailpiece or crupper, which hitches the back of the saddle to the tail. Some horses have a strap called a breastplate that goes around the front of the chest to help hold the saddle in place. Some horses are also supposed to wear martingales, extra reins to hold the head down. From all I can learn, a beginning rider is better off without one. If the horse tosses his head because he's unhappy with his bit, make his bit comfortable and don't jolt his mouth with your hands. If he carries his head too high, he needs reschooling, not having his head tied down. A standing martingale goes from his chin to the girth, and if it's tight enough to alter the way he carries his head, it will

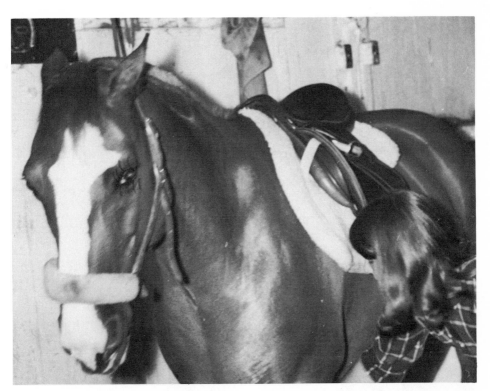

Some horses will bite when they are girthed up.

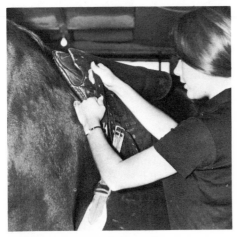

Fastening an English girth.

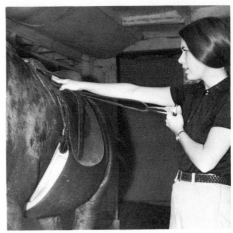

Check English stirrups against arm.

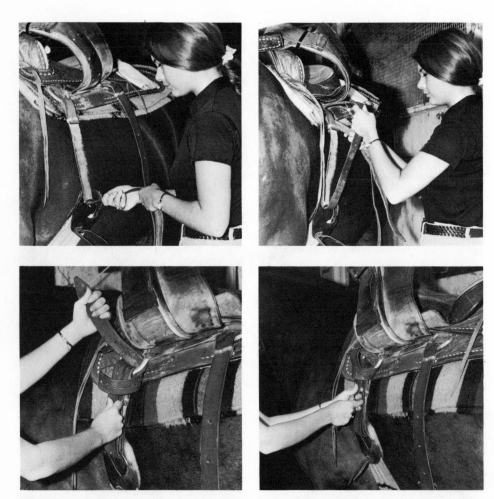

Fastening cinches on a double-rigged western saddle.
Preparing to tighten front cinch (top left). Then free end goes
back through top ring (and if too long, around again), then
down through top ring and out to left at back (top right). Bring
end across the front, from left to right, up and into ring (bottom
left). Then bring end down through horizontal part of knot.
Pull snug (bottom right). Always fasten front cinch first.

interfere with his balancing with his head if he jumps or stumbles. A running martingale is fastened not to his chin but to your reins and interferes with your rein signals.

On the other hand, a pony may need a checkrein to keep his head up. This will prevent his ducking for grass and perhaps spilling a small rider over his head.

With a Western saddle, you put the saddle blanket on first, laying it over the back a little ahead of where it belongs, and then sliding it back into place. Loop up the right stirrup and cinches or fastenings on the right side and then swing the saddle up into place. Western gear tends to be a lot heavier than English, but try not to bang the horse too hard. When the saddle is settled into place, go around to the right to check that all is smooth and in order; let down the stirrup and the cinch or cinches. Back on the left side, slip a couple of fingers under the saddle blanket at the withers (in front) and lift it up, to ease things over his backbone. Then loop up the left stirrup over the saddle or onto the saddle horn and fasten the cinch. If the saddle has two cinches, always fasten the front one first—and unfasten the back one first in unsaddling. This is because if the horse jumps and the saddle slips back, and the rear cinch is fastened but not able to hold the saddle in place by itself, the horse can get into an awful fight with the saddle and hurt himself. You may also be out of a saddle. Fasten your cinch with its buckle or knot, the front cinch pretty tight, the rear cinch not so tight. In general, you leave about three fingers' room in the rear cinch. Don't leave it hang so loose that the horse could catch a foot in it.

Bridling If you can arrange to bridle in the stall at first, your horse may be more cooperative.

Take off the halter while the cross-ties are still attached to it, let the noseband slip off the end of his nose, and refasten the halter around the top of his neck. If this does not give you enough control over him, just leave the halter on and put the bridle right over ·it the first few times until you get the hang of things.

When putting on the bridle make sure that any straps that

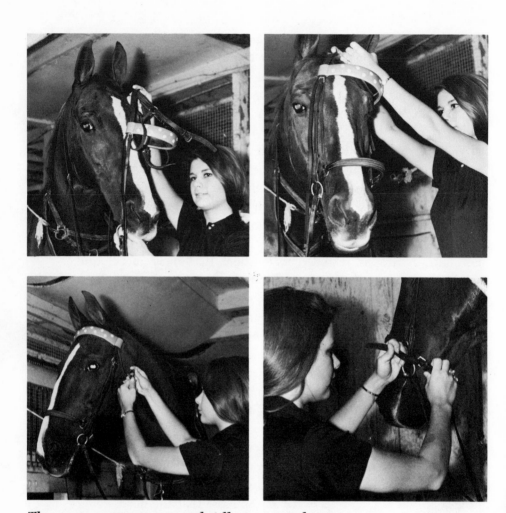

The proper way to put a bridle on your horse.
First, open his mouth (with a finger if necessary) to place the
bit (top left). Then bend his ear forward and slip bridle over
it (top right). Leave four fingers' width of space inside throat
latch (lower left). Allow two fingers' space inside the cavesson.
Keep the cavesson high enough so the lip won't be pinched
when you pull the bit (lower right).

go around his head or nose are undone, keeping just the longways ones fastened. In other words, the throatlatch is undone, so is the noseband if you use one, and the curb chain or chin strap if you use one.

Now for bridling. Put the reins over his head onto his neck. Hold the top of the bridle in one hand. Hold the bit on your open palm with the other hand. Hold the bit under his nose against his lips and be ready to lift with the other hand, gently, if he opens his mouth. Since you aren't sure what you're doing, he will probably not cooperate and will toss his head, turn his head, and keep his teeth clamped together. This is why you have him tied up. Try again. If he will not open his mouth, stick some available finger of the bit hand into his mouth and he will probably open up. Some really stubborn types won't open until you touch the tongue—the way through those teeth is at the side where there's a space with no teeth.

Once he opens his mouth, raise the bridle until the bit comes to the corners of his lips. Don't let the bit fall out again while trying to get the bridle over the ears. Hold the bridle up with one hand and with the other gently bend one ear forward (some say backward, they bend both ways) until you can slip the bridle over it. Then the other ear.

There you are. If you wish, you can now give him a rewarding tidbit right away, a bit of apple or carrot is better than sugar.

Now you can do up all the little buckles at leisure.

This is not the system of bridling you will find in the books. In the books you will be advised to hold the top of the bridle in your right hand and lay your right arm along the top of the horse's neck with your right hand sticking out between his ears over his forehead. Left hand takes care of the bit in the way we described. You are supposed to have more control of the horse this way. This may work fine with a pony or a horse that will cooperate. Whenever I tried it, the horse did some sort of jujitsu with his neck and sent me flying. With the frontal approach at least I wasn't overset and could try again right away.

By and by you won't have to leave the halter on under the

bridle. In fact you won't even have to tie him in all likelihood. He will just stand there and you will pop the bridle on like a professional.

You should be able to get two to four fingers under the throatlatch when it is fastened. You should get two fingers under the noseband if you use it, and between a chin strap and his chin. A curb chain should lie comfortably in the groove of his chin. If it's too tight he will be uncomfortable and will probably keep tossing his head. If it's too loose it hangs down and bothers him. See that the links lie smooth all along. You can make it smooth by twisting it back against itself (clockwise) before fastening it.

In winter, warm that ice cold bit in freezing weather, because skin sticks to freezing metal. We keep our bridle in the house and carry it down to the paddock inside our coat. Some people switch to a hackamore (no ice cold bit) for winter riding.

Some horses are headshy and you have to go through the bridling extra slowly and gently. Most of them will give you a hard time at first. Keep trying. Keep your temper. Don't give up, even once.

When you take off the halter, be sure to hang it up. Don't leave it for him, or you, to trip over.

To unbridle, you first lead the horse up to his cross ties and hitch them to the halter around his neck. Then undo the bridle's buckle under the throat, undo the curb chain and noseband, gather up the reins and the top of the bridle in one hand and slip the bridle forward over the ears. Then lower it gently as he opens his mouth and try not to bang his teeth with the bit.

If you're not tying him up when you unbridle him, leave the reins on his neck until you have put his halter back on so you have a little control of him.

In my pride at having got the horse undone successfully I would tend to overlook that I had left the gate bars down as I came in. Off would go the horse without even a halter to catch him by. Avoid this!

Leather care It's quite simply true that good leather well cared for will wear and wear, but neglected, will rot and fall apart. The

horse's sweat will rot it, dirt will rot it, it will dry out or mildew or both. Secondhand tack ("tack" means all those leather fixings of saddle, bridle, or harness), if it has been well cared for, is every bit as good as new.

If you can buy a beautiful new bridle and saddle, that's fine. Get as good quality as you can afford and expect to clean it at least once a week all the years you are riding, and every time it's dirty or sweaty besides. The perfectionist cleans it after every ride.

Western tack is cured differently and expected to stand up to much harder wear than English tack, but it needs cleaning and oiling too.

There are a number of systems for keeping leather clean and well fed and every saddler has his pet one, but they all boil down to removing the dirt and sweat and feeding the leather. The old-fashioned saddle soap, used with an absolute minimum of water, does a good job of feeding leather. But despite the name "soap" it's not the best soap for cleaning. For cleaning, use a mild soap like Ivory and a little water, or a drop of detergent in water (an old Teflon scrubbing pad works best, followed by drying with a terry towel). Then use the saddle soap once the leather is clean. If you keep saddle-soaping over dirt you get a remarkable layer of gunk on the leather.

There are various cleaners and tack restorers on the market such as Lexol or Miller's Tack Restorer, which both clean and feed—and do it very well.

Rain won't hurt your tack, but be sure to let it dry slowly, away from heat. When it is dry, saddle soap it thoroughly, or use your favored preparation.

Neatsfoot oil is an old standby, but other things do the job of suppling better, (Lexol for instance), except perhaps on stirrup leathers. Avoid using too much oil, especially on a bridle.

People will tell you these preparations rot stitching, but stitching is easy to have restitched, while if the leather goes that's the end of it.

That weekly cleaning consists of taking bridle and saddle com-

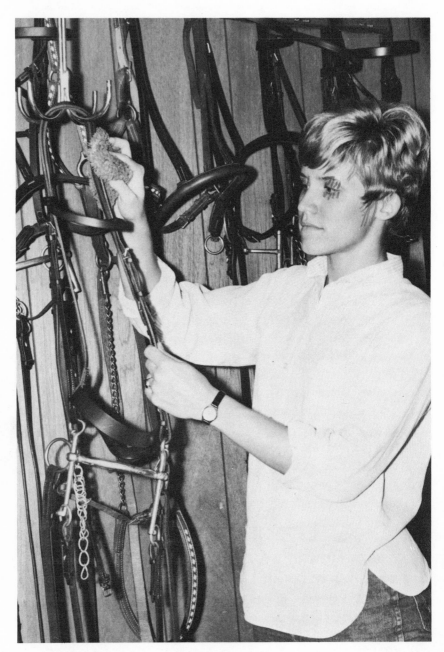

The bridle should be cleaned off before putting it away.

pletely apart, washing the metal pieces, cleaning the rest, and paying special attention to the places where the bridle and reins fasten to the bit, where the stirrup leathers take the weight of the stirrup, and the saddle's straps (called billet straps) hold the girth to the saddle. If any of these pieces are getting weak, have the repairs done before something breaks at just the wrong moment and you have a preventable accident.

It might be a good idea to take the bridle apart one buckle at a time for a while. There's no better puzzle than a bridle all in pieces, when you can't tell a crown piece from a cavesson.

Of course, the bit should be cleaned every time you put it away—a wipe with a damp rag will suffice unless your horse has been nibbling. And the girth should be clean because otherwise it's more likely to cause a girth sore, and that's a tedious and difficult thing to try to cure.

To help keep the saddle's shape, fix some way of keeping it on a bar or stand. The bridle should hang over something round (a coffee tin, even), not from one hook.

I assume that you use a saddle pad between the horse and the saddle. It protects the saddle from sweat. The cheapest pad for an English saddle is cotton padding like a bed pad, which is all right as long as it doesn't wrinkle. Its chief virtue is that it can be washed. A felt pad is often used. This is difficult to clean, and can get uncomfortable for the horse if the sweat and dirt cake on it. You can get that accumulation off by brushing (in one direction only) with a wire brush. Some people have luck washing the things. More expensive pads are sheepskin, or synthetic fibers like sheepskin, and these can be washed.

Westerners often use a Navajo blanket folded double, and they're really handsome.

Whatever kind of pad you use, make sure when you put it on that it rises up along the horse's backbone into the hollow of the saddle instead of binding across the backbone. If it binds, all your weight comes on the backbone, and this is one of the main things the saddle is supposed to prevent. If you get the saddle on and the pad has slipped down and lost its ridge, start over.

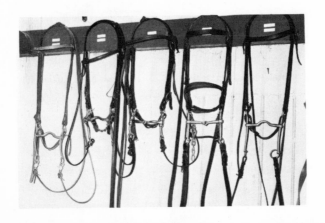

Both saddles and bridles will last longer if they are hung up over a curving support.

Does it fit? Just as you want your shoes to fit, the horse wants his saddle to fit. Get someone to check this for you. A lot of saddles nowadays are made to fit a variety of backs in adequate fashion, and it's remarkable what a good saddler can do in restuffing the underneath of the saddle so it will fit the horse better, but he can't work miracles, and the saddle must be basically right to begin with. (The saddle ought to fit you too and make a good position easy for you.) You can see how an ill-fitting saddle would let a lot of poundage (yours!) bear down on a few spots on the horse's back which would soon become sore—another awful nuisance to clear up.

Beware the secondhand saddle with a broken tree. This means the basic framework of the saddle is broken, and the saddle cannot protect the horse's backbone from your weight. This is hard to detect so a saddler or experienced horseman should check this for you.

Stirrups should be big enough so your feet are less likely to get caught if you are thrown. They should bear some relation, then, to the size of the rider's foot. One to one and a half inches wider than the foot is a good rule of thumb. Little people shouldn't ride with stirrups so big the whole foot could go through by accident.

People have devoted a lot of ingenuity to this problem of being caught by the foot and dragged. The bar where the stirrup hitches to the saddle often has a safety catch at the end—this should always be turned down so the stirrup can slip off, but on most saddles I know, the bar is so tight, the stirrup won't slip off anyway. Then there are Peacock stirrups, where the outside of the stirrup has a strong rubber band instead of metal—these are probably the safest rig going. Of course, if you ride Western, you can use hooded stirrups (tapaderos) where there's no hole all the way through. That takes care of that.

Also for safety, your shoes should have heels, to help keep your foot from slipping through the stirrup. Beware of sneakers or heelless shoes, or loafers which can catch the stirrup over your instep.

While you're checking the fit of the saddle, learn how the bridle should fit, particularly how the bit should hang in the mouth. The

bar of the bit should come at the part of the horse's jaw where there are no teeth, halfway between the biting front teeth and the grinding back teeth. One wrinkle at the lip corners is about right for most horses, but the teeth are the thing to check. The most common thing is for the bridle to be too long, so the bit hits against the front teeth and the horse keeps tossing his head. If the check-pieces bulge out when you pull on the reins, the bit hangs too low in the mouth. A bridle, once fitted right, can stretch, particularly if it's new, so keep checking.

The browband is one part of the bridle with no adjustment, and it may be too short, so that the horse's ears are squeezed at the bottom. It's easy to replace this with a longer one.

The bit should be the right width for the horse's mouth. Too narrow will pinch, and too wide will wallow from side to side and give poor control.

Better let the previous owner tell you what kind of a bit the horse is used to, or goes best with. Avoid a cracked or bent bit, or one that's worn where the side-pieces fasten to the mouthbar (particularly with a hard rubber bit). This can pinch the animal's lips and make them sore.

If you're on the beginning side as a rider, you have no business trying to ride with a double bridle or a strong curb bit because you just cannot manage them without hurting and upsetting the horse. By the same token, a horse that has to be ridden on a fierce bit is no beginner's horse.

A possible out for you if your horse is a bit too ambitious for you, or if you're still the kind of rider that ends up holding on by the reins (and we know what the horse thinks about that!) is to use a hackamore and not a bit at all. A hackamore controls the horse by pressure on his nose. Some of these are pretty fierce too, so get advice from an experienced person who can help you get and fit a mild hackamore.

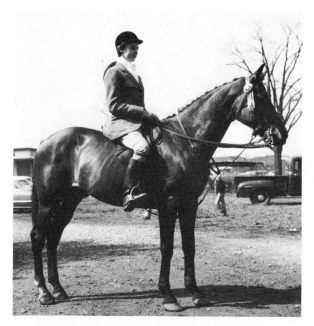

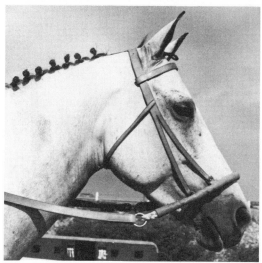

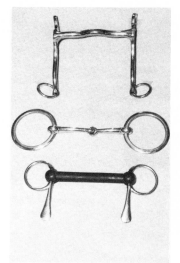

Standing martingale runs from noseband to girth (top). The jumping hackamore is also useful for winter riding without a bit (lower left). Some mild bits: Western curb with mild port, broken snaffle, half-cheek English bit with rubber mouthpiece (lower right).

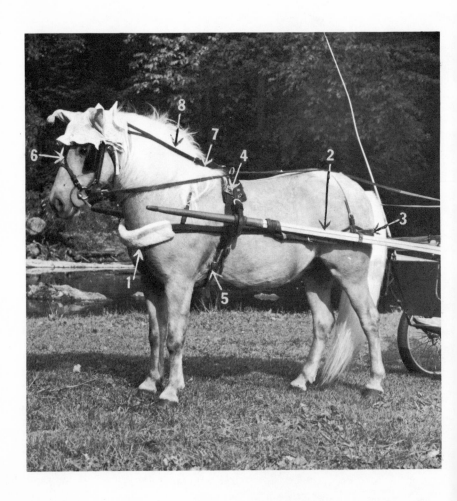

1. *Breastplate* 5. *Girth*

2. *Traces* 6. *Bridle*

3. *Breeching* 7. *Reins*

4. *Saddle* 8. *Checkrein*

PONY CART HARNESS

This looks like a major puzzle, but once you can think of what every piece does, things will be simpler. The harness does four things: the breastplate and traces pull the cart forward, the breeching holds it back going downhill, the saddle and girth keep the harness on the pony, and the bridle and reins give you control. There are endless variations in detail, but the principles remain the same.

The breastplate gives the pony something to push against. (Heavier ponies pulling heavier weights use a collar.) The traces fasten to the breastplate (or are part of it), then slip through various holders along the pony's sides so they won't flop down and get tangled, and run back to the cart. Pony pulls, the cart moves forward. (If the cart has a whiffletree, the traces fasten to that.)

The breeching (they pronounce this "britching") lets the pony hold back the weight of the cart going downhill by using his strong little rump. (If there are several of you in the cart, remember it is helpful to get out and walk down a steep place, so the pony isn't holding back too much weight.) The kicking strap over the back holds the breeching at the right level around the rump. The breeching fastens to the shafts by holdbacks.

The saddle goes on the pony's back to make a firm base for all the other fixings. It fastens around his stomach just like a riding saddle. Place it on his back at the lowest point, and see that the girth doesn't creep up too close to his front legs so it gets in the way of his elbows when he trots. From the saddle on each side are straps to hold the shafts of the cart; these are called holders or tugs, and they hold the shafts up. Along with the girth is a second strap called a tiedown which holds the shafts down. Get the person who sold you the harness to show you how these are supposed to fasten or wrap around the shafts, and which goes over or under what. The checkrein fastens to the front of the saddle

at the top. The crupper, that piece that loops around the tail, fastens to the saddle at the back.

In fine harness or racing rigs a thimble at the tip of the shaft is fastened to the saddle and is used instead of a breeching, and the traces run from saddle to shaft instead of from chest to cart. This is a very light fancy rig and you would only use it on flat ground and for special kinds of driving.

The bridle is similar to a riding bridle. It has a checkrein either over the head or at the sides. It may have blinkers so the pony looks only where he is going. Reins go back from the bit through the reinholders on the saddle to the driver in the cart.

To harness up.
1. Sort out your harness and make sure it is ready to put on. See that all the pieces attached to the saddle are set straight and looped up or tied up so nothing dangles and everything is ready for you to take the next step.

2. Tie up your pony or have your helper ready to hold him. (It is difficult to have a pony tied up where you can hitch the cart to him safely so I hope you have a handy helper. However, one person can do it.)

3. Put the saddle on his back, fasten the crupper under the tail, fasten the girth.

4. Put on the breastplate either over his head or around his neck. (Don't have the traces dangling.)

5. Put on the bridle. The checkrein is usually kept attached to the bridle. The driving reins are usually attached to the bit later.

6. Bring up the cart with its shafts up in the air. Bring the cart to the pony, not the other way around. The shafts are up so you won't poke him, trip him, scare him, or otherwise get into a mess when the shafts are among his legs and he isn't yet fastened properly.

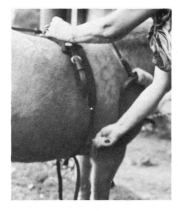

Adjust the girth

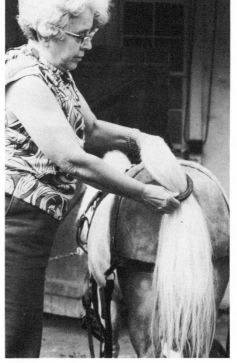

Put on breastplate

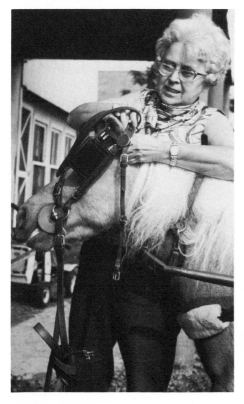

Bridle

Tail through crupper

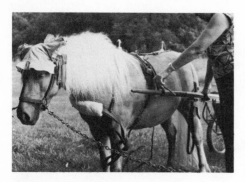

Shafts through holders

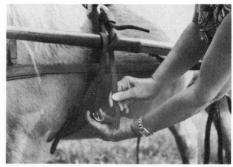

Fasten tiedowns

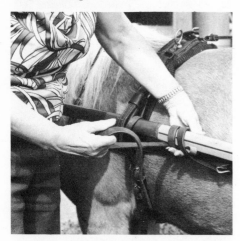

Fasten breeching straps

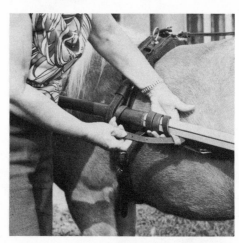

Adjust breeching straps

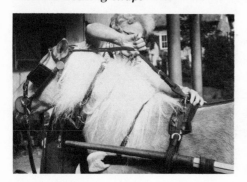

Put on overhead checkrein

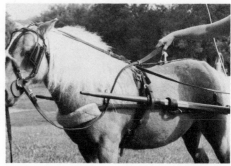

Gather up reins

Let the shafts down right where the holders are and run them through the holes forward.

7. Run the traces back to the cart or its whiffletree.

8. Fasten the tiedowns around the shafts and the traces.

9. Put the breeching on the pony and attach to shafts.

10. Thread the reins forward through the reinholders on the saddle and attach to the bit.

11. The last thing you do is fasten the checkrein to the saddle.

12. You are now ready to lead your pony quietly forward away from any obstacles such as gates, railings, or hitching posts. He must stand like a statue while you get in or out of the cart, and if he doesn't you should spend a lot of time, carrots, and discipline to teach him to.

To unharness, do all these things in reverse order, and loop or tie up all the long ends as you go so nothing dangles and spooks your pony.

Have someone who knows to check the fit of the harness with you. This is very important, since the harness must be adjusted all over for that particular pony. Each part must be right so your pony can do his job safely and comfortably. For instance, your breastplate must not be so low on his chest that it gets in the way of his front legs, or so high that it presses on his windpipe at the base of his neck. A girth should be tight, obviously but a breeching should only be comfortably snug as his legs move. The overhead checkrein has a lot of influence on how the pony moves, and racing and fine harness ponies lean weight on it and use it as part of their balance. For a pet pony lugging you around the countryside, it should be comfortably adjusted to the way he carries his head at a walk.

This pony has a will of his own but so does his rider.

6. Control in Riding and Leading

I'm not going to say a word about Forward Seat, Balance Seat, Saddle Seat, Western or English styles of riding. If you have not had any riding lessons, I beg you to get some. The pretty story in which the boy tames the wild stallion and learns to ride in the process is just a pretty story. The sad truth is that children who don't know how to ride will be unhappy, uncomfortable, and probably scared if turned loose on a horse, to say nothing of unsafe, and a child who is expected to tumble on and off a pony as good experience will probably end up doing just what the pony tells him to.

Some horses are gentlemen, but most ponies will take the quickest way to the life they prefer to lead—all food and no work. I know one nice little pony who has subdued three families one after

the other, not because it was bad or mean, but because not one of the children it came up against had the first idea of how to make it mind.

Making the animal *mind* is the key word—and if you have not had much experience your methods will be rough and crude, but you will have to use them (and try to learn better ones as you go along).

Riding your own horse on your own is a far different thing from riding a school horse in the ring or on the trail. There the horse hears the instructor's voice, and you have an experienced person to help you if the situation gets out of hand. With your own horse it's just between the two of you, and almost any horse will try you out to see what he can get away with.

The horse who is allowed to turn around to go back to his barn today, is the horse who may brush you off on a tree tomorrow to go back to his barn. The horse who snatches one bite as he goes along will soon be making your life a misery by continual snatching at tidbits—furthermore, he may pull his rider over his head, ducking for grass.

The horse who is allowed to decide that this is a good place for a canter may extend this to the point where you are careering around the countryside a good deal faster than you want to go. The horse who balks along at a certain spot must nevertheless go where you're telling him (it's up to you to see that there are no snakes, or wire, or broken bridges), or you will have a ride made up of balking, shying, and turning around to go home. I am assuming that you don't have the kind of horse who will buck you off and run home, but there are plenty of them. Ponies who consider themselves too heavily loaded will frequently unload their passengers. The horse's behavior when you ride him is a candid estimate of your riding ability, and if you're a novice he will try things he would never try on a more experienced rider.

All this means that, novice or not, you will have to practice insisting that he go where you tell him and only where you tell him, and at the speed you tell him. When the horse wants to go fast, that's the time to go slower, or the situation soon gets out

of hand. If you always canter across a certain open space, or worse, allow him to start to canter without being told, he will always canter there, so walk or trot instead now and then.

Do a few simple exercises with him on commands in a ring or field: for instance, start around the ring, whoa, walk a few yards, whoa, back three steps, walk forward, trot, whoa, congratulate him, and do it in the other direction. Next day a slightly different version. When you grow more skilful in using the reins without jarring his mouth, do this at faster speeds. He gets the idea that he must pay attention to find out what happens next—and that your whoa means whoa!

Remember when teaching him anything, a short lesson is better than a long one because he gets bored. Try every way you know how to end with a success, even the tiniest, so he can be congratulated or given a tidbit of carrot or apple once in a while to end on.

One good habit to set is to insist he stand still while being mounted. Another is always to walk when you get near home. Of course, if you are bringing him in cool, you walk much of the last bit anyway, but to insist on walking to the barn makes it less likely that he will bolt for home with you, a common fault. Furthermore, always dismount outside the barn.

If you get into difficulty, it's probably your riding that needs improvement, rather than a different bit, a crop, etc.

Until you have a good secure seat it would be a good idea to do most of your riding in company or close to home—you can see why. And after that, it's a good idea to say where you will be going, so when you're three hours overdue people know where to look for you.

Presumably your horse or pony had nice manners when you bought him or you wouldn't have bought him. Horses being such individuals, the way they behave with one family is no sure indication of the way they will behave with you. But if he's to keep those nice manners, it will take work on your part. It's a challenge that never ends, learning how to ride better and make your horse a nicer horse, more clever and obedient and fun to ride.

It's a matter of self-preservation, particularly if you're going to do any jumping, that your tack be in good shape, that you wear a hard hat or exercise helmet (helps prevent scrapes from tree branches as well as dents in the skull if you fall), and that your horse is in condition for what you're asking, and trained for that kind of jump, and that he isn't already overtired that day.

While we are on the subject of self-preservation, when you lead a horse by bridle or halter, keep his head or shoulder alongside you. If he gets too far ahead of you he can whirl and rear and strike at you with his front feet, or he can turn aside, bending the rope across his shoulder, and drag the rope out of your hand. If he is too far behind, you don't know what he's doing and may get stepped on.

If your horse is too much of a handful to lead quietly and keeps getting away from you (I can still see my two children skidding along at the tail end of a lead rope as the horse headed for some nice green grass he wasn't supposed to have), get a chain to fit over his nose in the halter. A lead shank is a lead rope and chain combined. Run the chain through the near side of the halter and across the nose and fasten at the other side in such a way that it will tighten freely but not slip off his nose. You can run the chain under his chin like a curb if you prefer. Then don't be afraid to give a good jerk at the moment he acts up. The beauty of this is that he won't try it again once you show him you mean business, so you can both be comfortable from then on. He must lead quietly or you're not safe and he's learning bad habits.

Of course, you may have the opposite problem in leading. The horse stretches his neck accommodatingly in the direction you want him to go, but somehow the feet don't follow. In that case you or a helper should give him a good lick in the rear with a switch or rope. He may move forward a bit faster than usual in this case.

Face the direction you want to go, and stand beside the horse, and cluck or whatever your go signal is. If you face him, he doesn't think you can possibly mean for him to move forward.

Often when a horse balks you can start him going by leading off to the side instead of forward. He moves his feet to keep from

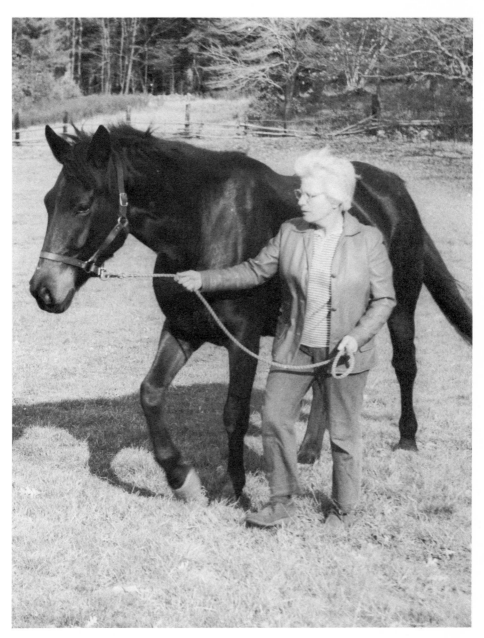

The safest way to lead is to keep yourself in line with the horse's front legs.

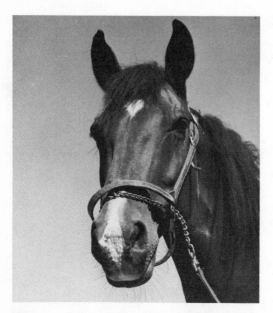

Chain of lead shank can go over the nose . . .

. . . or under it like a curb chain.

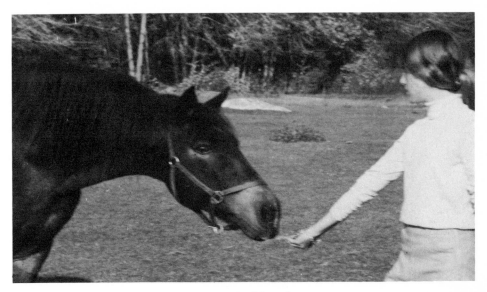

Most horses will come to your outstretched hand.

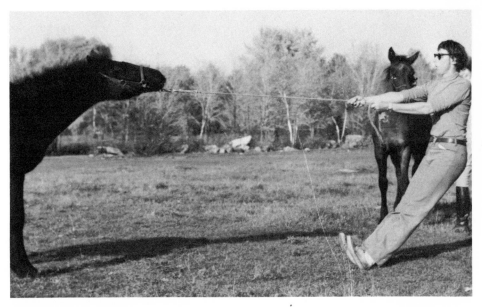

If you pull, he will just pull harder.

being pulled off balance, and once his feet are moving he sort of forgets he wasn't going to move them.

When you get to the place where you're turning him out, don't just leave go of him. He may go frisking off kicking his heels in the air and you may get kicked. Lead him a length or so into the field and turn him to face the gate before you unhook the rope from the halter, and he has to turn before he explodes. You're far enough from the fence to have room to duck.

If you go to the pasture to catch your horse and he's all alone, chances are he will come to you for company. If he doesn't come, he may let you walk up to him. If he's the kind who turns his rump in a threatening way, get a horse person's advice on how to handle this particular beast, because that's an unfriendly gesture, and he knows very well he shouldn't do it.

If your horse is out in a pasture with several others, there may be an occasional scuffle, so don't get caught in the middle. There will be a boss horse, who always shows fight, and somebody at the bottom of the pecking order, who always runs away, and there may be some biting and kicking in between. Need I add that stallions are usually more rambunctious, and mares in heat more unreliable, and mares with foals not to be approached at all unless the owner is present?

It's safest to approach your horse from the front, in field or barn. Horses often sleep standing up and if you startle them awake they may lash out. Speak up as you approach so they know you are coming.

One more item. Your horses's protective shots are up to date, I hope. I trust yours are too. It seems to me we were always getting tetanus boosters those first few years. One child drove a pitchfork into her foot. Another lost the nail off her big toe riding a pony barefoot. Our house rule is "shoes in the paddock," and once a horse has stepped on your foot you will probably have the same rule.

7. Barns and Fences

Elegance no object, your real concern here is the horse's safety. Is the stable or shed reasonably draft-free, but also reasonably well ventilated? Is the floor safe and clean, are there no loose boards the horse can paw up, no rotten places, no hollows in a dirt floor where he can lie down and be unable to get up? If the floor is cement, I hope it's temporary, because cement is hard on feet and elbows and hocks. You could add a layer of wood plank, though it will rot quickly. My expert friends say it's better to send for a jack hammer and break up the cement. Meanwhile, bed deeply, at least six to eight inches.

Is the siding strong and smooth, with no splinters or nails he can hurt himself on? Is any manger arrangement strong and smooth, as well as easy to clean? Are any windows and lights protected

with wire netting or bars? Is the ceiling high enough so he doesn't hit his head if he lifts it high in alarm? You don't have to make the ceiling so high he can't hit his head even if he rears or you'll be housing him in a silo. Eight to nine feet is a reasonable height.

Is the doorway wide enough so he doesn't bang his hipbones on the way through—horses are clumsy that way, and can even break off the tip of the hipbone. Try for a four-foot opening.

Plenty of horses in this world have spent their lives in straight stalls, walk in at one end and manger at the other end, and the whole thing only about a foot wider than the horse each side. They even manage to lie down at night. So if this is all the room you can manage, OK. If you can spare eight feet by ten feet or so for a loose box, this is more comfortable for the horse and better for his general circulation. Twelve foot square is even better. For some funny reason, once you have this stall properly bedded, it doesn't take any more clean bedding to run than a smaller stall.

If you can arrange so he can go in and out at will most of the time, this is ideal.

The minimum The simplest setup for a pony or rugged horse like a Morgan or a bronco is a shed with roof and two or three sides, just something to keep off the worst of the wind and the rain. It would be hard on a thoroughbred in a cold climate, unless you kept him well blanketed, since he usually doesn't grow much of a fur coat of his own. The drawback to the shed arrangement comes the few times you would like to put a horse inside, when wet for instance, or if he's ill.

So if you can manage to have a shed that shuts, that will work better, and you will be easier in your mind in blizzards.

The ideal The ideal setup, of course, depends on your climate and surroundings. In the north temperate zone it's a neat little building with a comfortable-sized box stall with dirt floor, and a Dutch half-door to the stall so he can have a window into the sunshine at times you don't want him to go out. It has someplace to store a ton of hay, a good bit of feed, and some bedding, a tack room to keep bridles, saddles, blankets, and miscellaneous gear,

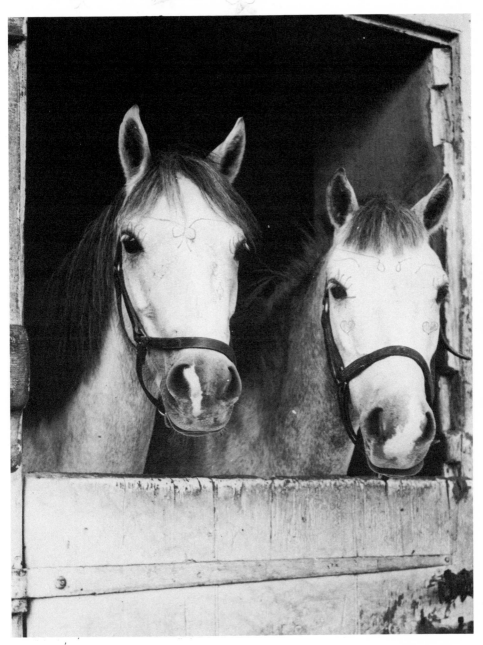

As happy as they appear, two horses should never be put into one stall.

Here is an elegant version of "a shed that shuts."

and hot and cold running water at hand. A paddock outside the stall door is also included in this ideal setup. Then, while you are wishing, you can include pastures, more than one so that you don't have to let any get worn out and eaten bare, also so that you can reseed and refertilize to keep up the nutritional quality of the grass, and so you can shift around which one you keep the horse in year by year to break up the worm cycles.

When arranging your barn, keep the danger of fire in the back of your mind. A horse will not save himself from fire; his brain tells him his stall is the only safe place in an emergency and there he will stay. He will even run back to it from outside. So take extra care with any electric installation, and with hay storage, and outlaw smoking. Horses have even died because trash paper blew against a powerful electric fence, and set fire to dry grass which spread to the barn. This is also a reason to think twice before having your pony share the family garage along with oil cans, an extra gasoline can, paint, turpentine, and other inflammable items.

You want to see to it that the paddock is well drained, not a sea of mud in February or March. You want to keep the manure scraped up out of the paddock, particularly if it is small. This is his chief standing place and rolling place.

If the stall has a dirt floor (the best kind), you probably will gradually wear it down as you clean it. Be sure to keep the dirt reasonably level—holes and hollows are bad for their legs. Whenever necessary, perhaps every six months, you can dig it out a bit more and start fresh with some new dirt. You don't want to keep the same soaked dirt underfoot for years. What kind of dirt depends on what is available in your vicinity. Ask a stable owner what he recommends. In our region it's something called "crushed gravel" which bears no resemblance to "gravel" but is a rather light clay that drains well and packs well.

Fences Fences also depend on what is available in your part of the country. A boughten post-and-rail fence is beautiful if you can afford it, or post and boards, painted white (no lead paint, just like for kids). But whatever it is, assume the horse will hurt himself on any loose nail or broken place, and keep it mended.

A fence of wire netting should have such small spaces that he can't possible get a hoof caught. This is particularly important for ponies. Any horse will paw at the bottom of a fence. It's all right to have the kind of netting that has very small holes at the bottom, and larger ones higher up, if they get bigger above where he would be pawing.

One neat trick is to have wire fencing three and a half feet wide, raised one and a half feet above the ground. It's easier to put up than wider fencing, and takes care of the pawing problem since there's nothing at the bottom to paw.

The ideal way to keep any animal away from a fence you don't want him to fool with is to put one strand of electric wire along the top or the inside top. This will protect a fence that has seen better days. A line of electric wire, rather high, will keep horses in separate fields from playing biting games over the fence, if you have that problem.

What about electric fence alone? It depends a bit on the horse. He has to be smart enough to understand it, and quiet enough to put up with it. A pony with a thick coat, or a high-spirited horse or stallion who wants to reach another horse outside is likely to ignore the shocks he gets from the wire and go straight through. But at the moment this is what we use, with good success.

You can run your fence from house current or on batteries by means of a fence charger. Some people turn their fence off a good deal once the horses have learned about it, but I always got in trouble that way. Eventually, mine would try again and then make a break for freedom. I don't think they were smart enough to figure out that the tick of the charger meant the fence was on, though. A cat can figure that out—in fact a friend's cat used to scratch its back on the bottom wire, between ticks!

A fence will be more or less grounded, and the shock therefore weaker, if there is wet snow on the insulators, or if wet trees are leaning on the wire, so you have to check your fence line in bad weather. A handy gadget I recommend is something called a fence tester, which keeps you from having to test the shock yourself.

Horse heaven enclosed in a post-and-rail fence.

One strand of electric wire makes this post-and-board fence super secure.

You won't have this nice post-and-board fence long if you tie your horse to it. One good jerk and your horse is tied to a loose board with nails sticking out of it.

Informal fencing works well but needs to be kept in good repair.

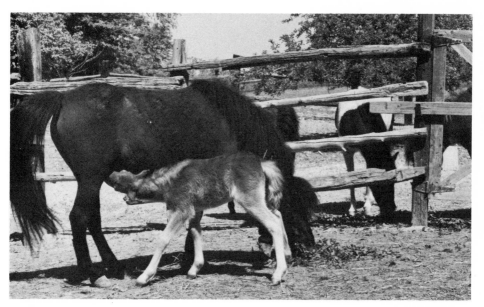

Even the smartest pony isn't going to escape under this fence.

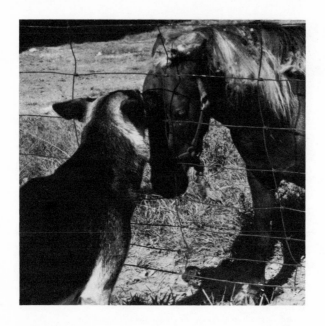

This wire fence is dangerous because the pony could catch his hoof in the narrow sections near the ground (top). Tie twine or rags on a wire fence so your horse can see it (bottom).

A horse standing on snow will not get a strong shock, as the snow is insulating, preventing a good ground from fence through horse, but fortunately horses are not as ambitious about getting out in a heavy snow.

How do you teach a horse about electric fence? Pick a day when it has been raining so the ground is wet, but the insulators have dried off, so you get a good strong shock—or else wet the ground where the horse will stand. Now put some feed where he can reach it outside the fence and stand back. He will try to reach the feed, and get a shock, and jump back, and try again, and jump, and try and jump, and try a little further along, and jump, and haul off and cuss a bit, think it over, try again, and finally give it up. Do this several different places along the fence on several different days until he just gives you a horse laugh and doesn't even try for the food. Finally he gets the point that it's the wire that's jolting him. Then you can assume he will be safely contained behind the wire.

One result of this may be that he develops a very sharp eye for any wire (a good thing too), and may refuse to go somewhere along a trail because there's a wire on the ground, or through a gap where there once was a wire. But that's easier to cope with than a horse who walks through fences.

No, the current won't hurt him, it will just surprise him. It's stepped down from house current in the charger. House current could kill him, and you too.

Whatever you do, try to avoid barbed wire. Western horses are usually smart enough to stay out of trouble with it, but it causes really horrid accidents.

Horses as escape artists No matter how carefully planned your stable and paddock are, or how well they kept in the horse who lived there before, you won't be sure they will hold your new horse until the horse has tested them.

A horse has about twenty-four hours a day to work out the problems of getting out for a gallop in freedom, or getting into the feed, and some of them really give their minds to it. One week

in spring, our first horse escaped four times, each time a different way. Once he leaned on the fence with his rump (not an electric fence, I may add) and pushed down a weak post. Next he removed the middle of three rails by wiggling it with his strong nose, and in some remarkable fashion skinnied under the top rail and over the bottom rail. One time he found out how to undo the latch of the gate, and just walked out. We bought a chain and padlock for the gate, so the next time he broke the gate at the hinge side.

Our next horse was an artist at putting his heavy neck under a rail and lifting. He could break a two-by-four any time he wanted. He broke the gate three times before we electrified it. He hasn't broken it since. Didn't learn very fast, did we?

Some horses can undo bolts. Some can even undo snap locks—they say—I hope never to meet one of those. One horse I knew just used to lean against the heavy webbing arrangement which closed his stall until the screw eyes pulled out of the wall. Ponies, of course, are famous for rolling under a rail or wire.

So keep an eye on your horse for a week or two and see what surprises he has in store for you. (With this in mind, we keep halters on our horses all the time. It's a balance of risks, the risk of their getting their head caught, or a foot caught in the halter, and the risk of their getting out and nobody being able to catch them if they have no halter on. It paid off, I thought, the day our two horses escaped through a broken gate, hunted up the nearest four-lane highway, and went for a good gallop in the middle of the Saturday morning traffic. A heroic 4-H leader led them out of that mess with a rope and her belt. That was the day we electrified the gate!)

Another word about halters and safety. If the horse is turned out where nobody sees him all day and there's a good deal of brush or trees, the safest thing is for him to wear a halter with a weak place in it, so if he does get caught he can break free without damaging himself.

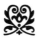

8. Summer and Winter

We all have an idyllic picture of summer—green grass, shade, horses or cows in a peaceful vacation scene. You may have missed the fact that the happy horses were stamping quite a lot to get the flies away and an occasional pair were standing nose to tail and swishing continuously for the same reason. Some people I know keep their horses in during the day in summer and let them out at night, just on account of the bugs. They are a misery.

It helps to use a reliable fly repellent on the horse, stuff like Wipe or 6-12. Beware of some of these strong insecticides, however. Be sure what you use is good for horses. Rather than risking the use of poison to spray the barn, use screening and fly paper or black light. If the barn is good and dark, there will be fewer flies. Even with a shed, or walk-in-and-out arrangement, you can hang

up gunny-sacking to make a dark shaded place and let the horse push in or out. I was surprised to find how much the horse stayed indoors in summer, given free choice—he was in a lot more than in winter.

In late summer the botflies will appear—they look like a curled-under horsefly and lay tiny little yellow eggs on the horse's fur, mostly on the legs. The horse swallows an egg, it hatches into a botworm inside his stomach, and can cause a lot of damage. Your vet tries once a year to clean out the worms. You can help by touching the eggs with kerosene, careful not to soak the horse's skin which might get sore. The kerosene kills the egg so it can't turn into a worm. Picking the eggs off yourself is tedious and difficult. You can scrape them off with a knife blade (risky) or use a safety razor, or pick them off one by one (they stick, unfortunately), or even rub them off with sandpaper. Sponging the eggs with water about 103° will cause them to hatch and die.

A horse, just like a man, feels the heat and can get sunstroke or heatstroke if left in the open all day with no shade. He gets extra thirsty in hot weather, just like a person, and likes a sponge bath or going swimming.

When bathing a horse, don't use ice cold water straight out of the hose. In fact, a lot of horses don't like hoses at all anyway—too much like snakes. A bucket of lukewarm water and a sponge work better. Don't get water in his ears; he will act worse than a three-year-old.

To dry him off there is a handy gadget called a sweat scraper. Then you can towel him, and then walk him about until he's dry. This way you're sure he didn't get chilled, and what is more he hasn't rolled and got dirty all over again. He will as soon as you turn him loose though.

If it's a chilly enough day so you wouldn't like to dry your hair out of doors, skip the bath, or put him indoors with a cooler on until he is dry. (The use of the cooler is explained in the next chapter.)

Ever seen a wet horse shake himself like a dog? You'll be wet!

If you want to go riding in very buggy weather, some extra

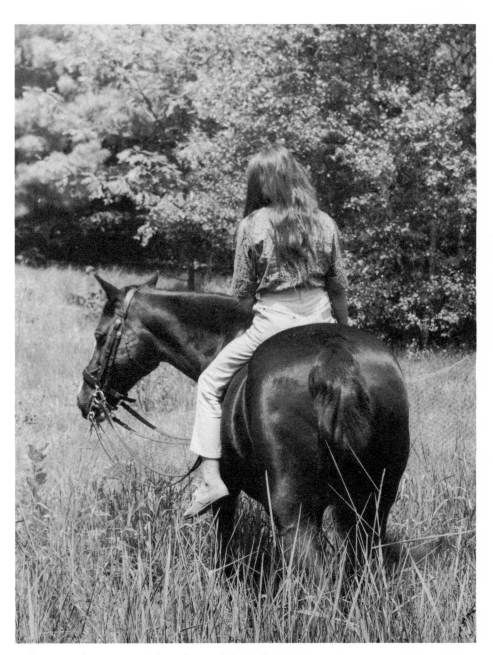

A horse and summer make a beautiful combination.

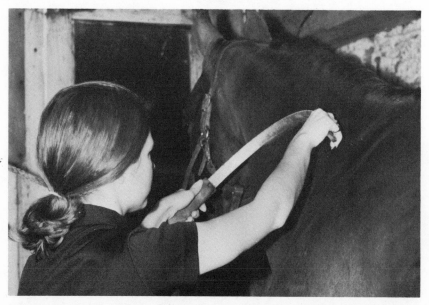

*Cloth or crochet, a fly-hat is a blessing (top). This "shed'n blade"
is a sweat scraper on the smooth side and a sharp-toothed edge
on the other for combing out the old winter coat (bottom).*

insect repellent is certainly useful. Some horses wear little cheese-
cloth hats which keep the bugs out of their ears, and you can leave
such a hat on in the pasture under the halter if they seem to get
badly bitten. Looks silly but the horses seem to appreciate it.

Use your head about exercise in very hot weather. Assume that
the horse feels about as you do about the weather—you'd rather
ride in the cool of the evening too, wouldn't you? On the other
hand, he can get adjusted to hot weather work the same as you
can.

Cold weather As a general thing, horses do better in cold
weather than in hot. You can't use your own feelings about winter
as a guide to your horse's point of view as well as you can in
summer. The horse gets adjusted to the cold weather the way you
would if you lived out of doors all the time. Going in and out
of a heated house throws our adjustment off, but they say the quick-
est way to make horses sick in winter is to heat the stable. So
unless your horse is sick and the vet orders heat, never never "take
pity" on him by heating his stable.

In winter he likes to keep dry and out of the wind, but pure
cold doesn't bother him. He needs more food to burn for fuel; how
much more depends on the individual. He doesn't ask for as much
water as in summer, but he needs water to go with those dry winter
foodstuffs. If it's so cold that the water freezes in the bucket inside
of an hour, you might offer it to him several times a day. We
always give warm water in that kind of weather, so it won't freeze
so fast. There's a little electric water heater gadget to take care
of that problem, though you have to be careful how you rig it
so it will be safe.

Nobody seems to have told horses not to eat snow; mine would
eat snow even with fresh water in their pails.

Urine sometimes leaves red marks in snow, but the horse's urine
is pretty concentrated anyway, and this is nothing to get alarmed
about.

Clothes are a problem, and fortunately lots of ponies and Mor-
gans and mustangs and other hardy horses with a thick winter coat
don't need extra clothes.

We have a walk-in-and-out system, so I bought a raincoat for each horse to keep them dry on those blizzardy, slushy, wet, miserable days when they didn't choose to stay inside. (The best kind of raincoat I know is a New Zealand rug because it hitches a special way around each hind leg and stays on—they're a bit more expensive.)

One horse we had was a young Morgan, and we used to put a blanket on him below zero, but I don't think he really needed it. The other horse was old, and we used to blanket him below 15° or in a bitter wind. You could feel that he wasn't as warm under his fur as the other.

If you operate a stable system where the horse stays in unless you let him out, blankets are all according to the horse's metabolism, and it would be worth asking the previous owner what he did.

The trouble with blankets comes in the spring. For instance, if you leave the blanket on on a bitter morning and the day warms up faster than you thought and the horse is sunbathing, anyway, as he will as soon as the sun hits the paddock, you find he's hot or even sweating under his blanket, and then you have a problem with getting him dry without chilling. Better to take the blanket off too soon than too late.

Anywhere that you get ice underfoot, your horse should have winter shoes, both for his safety and yours when you are riding him. Nowadays, winter shoes have spots of borium on the bottom which dig into the ice. They also wear well, so the shoes you have put on in December can probably be reset and see you through the winter. If not borium, at least have him "sharp shod." Some horses who are shod only in front in summer, when the only problem is wearing down the hooves, will need four shoes in winter to keep from slipping. (Of course, if several horses are turned out together, you want to avoid hind shoes if at all possible.)

Next safest after sharp shod is barefoot, as the frog and edges of a well-trimmed foot are somewhat nonskid. This is far better than ordinary shoes, which are a menace once you have ice.

Another thing to think of with winter shoes is pads. These are a layer of leather or rubber right across the whole bottom of the

The New Zealand rug is warm, waterproof, and stays straight because of its special hitch around the hind legs.

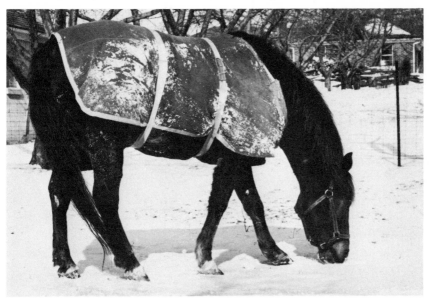

If this pony lived out, he'd grow his own winter coat and wouldn't need the extra clothes.

foot, between the shoe and the foot. They keep the snow from balling under the hoof so much, another cause of slipping. The hoof under the pad is stuffed with oakum and antiseptic tar of some kind, so it stays healthy underneath, and you have a lot less work cleaning feet in the worst weather.

Some people pad their horses' hooves year round, but my guess is that you have to start with awfully healthy hooves not to get into trouble.

In winter you may just turn your horse out and not ride him. You may not groom him much either, as too much brushing will remove the waterproofing in his coat. You want to handle him enough to keep him tame, and make sure you don't miss any cuts or other problems.

If you do ride him, you have to be fussy about getting him fully dry afterwards without his getting chilled. (You can assume that any exercise he takes without a rider won't overheat him enough to bother.) To save a lot of trouble in drying the horse, people who ride in cold weather usually have their horses clipped, particularly underneath where the thick winter coat gets so wet and takes so long to dry. If this is done early in the fall, the fur has grown back to a useful length by the time the worst of the winter arrives and most everybody stops riding.

In cold weather, even a quiet horse gets pretty frisky, and may rare about and buck. Then you want to longe him before you go riding—that is, exercise him on a long line before you start to ride, to get some of the frisk out of him. It might be a good idea to get a lesson in longeing from your riding teacher.

My own enthusiasm for winter riding is nil, but some people ride religiously all winter. Bareback is warmer, and you don't have to worry about his being hot under the saddle and then getting chilled there when you take the saddle off.

You don't have to stick to just riding in winter. If he's broken to harness, you may be able to go sleighing, or with a rider he might tow someone on skis (find out a safe rig for this from someone who knows). He can even plow your driveway for you, but he needs a proper harness for the job.

Winter shoes are a necessity for this kind of fun (top). Horses
prefer the outdoors even in cold weather (bottom).

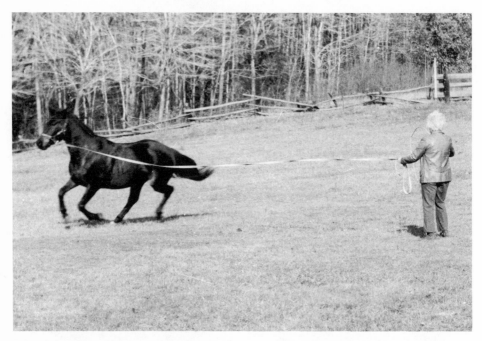

Longeing your horse is a great training aid, also useful for settling him down before you ride him.

9. Keeping Your Horse Healthy

The Ounce of Prevention The most important idea in this chapter is to try to set up your system of care so your horse will stay healthy.

The chief elements in his health are food, water, and regular exercise. Food and water we have already dealt with. Exercise is equally important because a horse is like an athlete—it's good to have him in condition and keep him in condition, or if he's having a slack time (as in winter perhaps) you don't ask him to do too much with his out-of-condition muscles. If he's kept in a barn all week, he's not really up to an all-day jaunt on Saturday. Which isn't to say that you have to let his daily exercise become a bugaboo, but only that you don't ask too much extra of him beyond what he's used to and is in condition for. A horse seems strong because he's so big, but he can get soft just like anybody else. You don't

catch a ballplayer pitching a big game after a winter layoff without working up to it, and a pitcher's arm is more like a horse's legs for giving trouble than anything else I can think of.

Starting in spring after a lazy winter, begin with mostly walking. A prime conditioner is riding up and down hill at a walk, and later so is a good deal of steady trotting. Keep track, so you can make steady progress. Push him along a few days, then ease off a day or two, then push him again for another few days. Soon he won't be puffing at the top of the grade.

Be sure you work both diagonals equally at the trot and both leads equally at the canter.

Just from the point of view of keeping his insides working smoothly, a horse that lives in a stall should get out every day, even if only in a field where he can prance and roll a bit. That is where a walk-in-and-out system and a paddock large enough for a good run will save you some trouble.

Another art to learn in the care of your athlete is "cooling out." This means getting him cool and dry after he is hot and sweaty from exercise. The procedure at a race course gives you an idea how important this is. After a race, the hot horse is covered with one or more layers of porous wool (these are his coolers) and walked and walked. His coolers, as they are soaked by sweat, are replaced with dry ones. He never catches a chill from standing around wet in a breeze. And he's allowed only a very little water every fifteen minutes until he's cool and dry, and of course nothing to eat until he's settled down. His legs don't get stiff from suddenly stopping exercise, and his whole system settles down gradually—the way a runner will jog after a race instead of sitting down panting. Most of us don't ask as much of our horses as they do of racehorses, but we still have to take care. That accounts for the old adage about walking the first mile out and the last mile back. Particularly the last mile back. This means you arrive at your paddock with a relatively cool horse, not one all panting and tired.

In some weather, particularly in fall and spring when he has his winter coat on, he will nevertheless be wet, even though you walked him home. Are you going to turn him loose in his wet

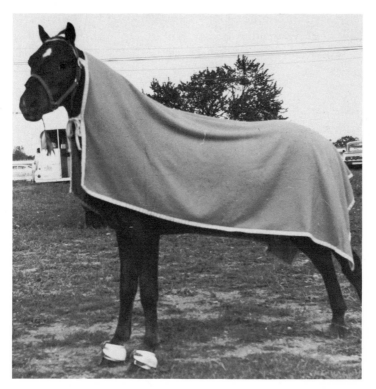

A light wool cooler helps your horse to dry off without chilling.

coat? Better not. This is the time to use your cooler (the most important cover in your tackroom). Put the cooler on and fasten it well across the chest, and walk. If the horse is thoroughly cool and not blowing or puffing but still damp you can put him in his stall out of the wind with the cooler on and check back in an hour or so. After the horse has worn this blanket for a while, you can feel that the cooler is wet but underneath the horse is dry. Magic, but it works. Remove the cooler once it has done its work, and dry it.

The best coolers you can buy are made of light wool, warm and absorbent. You can also make your own, with different versions of wool or thermal blanketing. Just remember it should be light and porous. (There's a kind of net stuff which is getting popular with holes nearly an inch large in it, rather like the bottom layer of arctic underwear. It's meant to be just that, a bottom layer, and not to be used by itself.)

Suppose some day you bring your horse in really tired out. A good toweling will feel good to him and cut down on the drying process. Rubbing his lower legs with something like Absorbine or rubbing alcohol will feel good too. The professionals sometimes bandage tired legs, but don't try that unless you really know how to do it. And what about supper? Cut down on the grain or concentrate and let him have mostly hay.

Worms A horse picks up worms in pasture and on hay and in his own stall and bots from eggs the botfly lays on his fur. This is why you give the hay in a manger or hay box if you can arrange it, rather than on the ground. This is why you don't particularly want him to graze much in his paddock, but rather in a pasture where the land can be rested every few years to break the worm cycles, and why you don't spread his manure on his pasture. (All this varies according to the severity of the winters in your part of the country, so you had best ask somebody who knows.)

Anyhow, you can depend on his having worms, which can do him a lot of harm unless you get rid of them regularly. So set up a program with your veterinarian. No less than once a year

for bots, and no less than twice a year for the others, depending on the kind of medication you use and how quickly the horse gets reinfected.

You can't tell if a healthy-looking horse has worms—just assume he does. If he has a poor coat—or if he doesn't shed his winter coat neatly about when you expect—or if he scratches his behind frequently—or if he's shedding flakes of skin around his anus—frequently the answer is worms, so act accordingly. In fact, any time your horse doesn't look in the pink, consider some problem of his nutrition, a lack of proper feed, poor teeth (see below), or worms.

You worm for bots in late fall after frost. Most of the other bad worms (except possibly roundworms) can be taken care of with a worm powder which you can buy from vet or feed store. You will need to use this at least twice a year; and if your horse can pick up a lot of worms, every two to three months. The stuff usually comes as a powder you give in the feed. The average horse will eat this without fuss, but I have never had an average horse yet. We had a lot of well-wormed squirrels once, who ate the grain our indignant horse tossed out of his bucket. We finally managed with him by pouring molasses over the grain and medicine. But that wouldn't do for our next horse. With him, we gave hay but no grain for breakfast, and grain but no hay for supper. The worm powder went in the evening grain, and although he stamped off when he discovered it was there, we hung it in the stall, and with nothing else to think about all night, he eventually cleaned it up.

I have one friend who puts it in strawberry jello for her fussiest ones. She sprinkles a package of jello into the feed once a day for several days and then adds the worm powder along with the jello once the horse is used to the new taste.

As you can see, this is another thing worth taking trouble over.

Prevention of some common infectious diseases. Most horses have their tetanus immunization boosted once a year, and this is a good idea since the horse is one of the most vulnerable animals to this disease, and the organisms, of course, are present in manure.

Most horses have shots against the three U.S. strains of equine encephalitis as well. A new strain, Venezuelan equine encephalitis, has come into this country, and depending on how it spreads, your horse should probably be protected against it as soon as vaccines are generally available.

Equine infectious anemia (swamp fever) is another serious disease prevalent in some parts of the country. You should know about it if you mean to travel with your horse or are getting one from a distance. Unfortunately, there is no cure for it yet, and apparently the few horses that recover can give the disease to others while seeming healthy themselves. Until more is known about this one, quarantining is the only helpful thing, along with the destruction of carriers. There is now a reliable test which can establish if this is what a sick horse has.

Colds and flu (see Shipping Fever, below) can sometimes be prevented by shots and these are worth looking into if you are showing often or coming into much contact with strange horses. If you go to a show, be sure to take your own buckets for water and food.

For the rest, keep your horse away from unhealthy looking horses and stay away yourself.

Teeth. The vet should check the teeth once a year, since a horse's teeth keep growing and sometimes wear down to sharp edges which hurt when he chews, so then he's poorly nourished. When the vet files down the sharp edges, this is called "floating." The horse minds this less than you would, since there are no nerves in the exposed portion of the teeth.

Shoes A good blacksmith is a rare blessing in any part of the country. Ponies usually have good strong feet and can go barefoot, as can many horses, but even these need to have their feet trimmed by the blacksmith. Even if the horse is keeping his hooves worn down to the right length as he goes along, it's a rare horse that wears his hooves down evenly, so his feet get more and more run over, just like a pair of old shoes all run over at the heels, and this is a strain on his legs and can lead to lameness.

If there's a lot of stony ground for your horse to cover, or you have to use hard roads much, you will have to have him shod, because otherwise he will wear his feet down too fast to the quick and then he will be lame. Sometimes only the front feet, which bear most of the weight, will need shoes. Anyway, try to arrange to have the feet reshod often—depending on the individual horse, every four to six or eight weeks. The troubles you can get into when the feet grow too long are countless: cracks, stumbling (a menace to the rider), damage to the tendons from the wrong angle, damage to the joints. Some fancy show horses have extra long feet as part of their show points, but if you have one of them you know what you're in for and can allow for it.

As the foot grows, the nail ends may rise and stick out, so the horse could cut the opposite leg with them. Bend them down again while waiting for the smith.

Sometimes a shoe will get loose, and if you really see daylight between shoe and hoof, better not ride until you can get this fixed, because the horse can catch the loose end in something and damage his foot. If he pulls the nails loose and then steps on them, you have real trouble. Try and get the smith as soon as you can so as to prevent this.

If the shoe gets bent so the horse can't stand naturally, and the smith still doesn't come, you should ask some horseman friend to take the shoe off for you. You can learn to take off the shoe yourself—it's just a matter of the right tools. You need to be able to cut or file off the clinched ends of the nails that are bent over on the outside of the hoof. Then you can pry off the shoe, drawing the nails out of their holes. This is strictly an emergency procedure, and it's hard on a horse to be standing one shoe on and one shoe off (you certainly wouldn't ride him in this state), so holler for the smith.

If your horse or pony goes barefoot, and a blacksmith is as rare as snow in July, you might consider learning how to trim feet. Hunt up a blacksmith or horse vet or an agricultural college and learn it right. Of course, out west every cowboy knew how to shoe his own horse—he had to. But the trick of getting those curved

A blacksmith's care is vital to your horse's health and usefulness.

nails in so they hold the shoe on but miss the quick of the horse's hoof inside there doesn't make me anxious to try it. Even the best smith misses sometimes and then you have a lame horse who has to have his shoes reset the day after they are put on.

Thrush Thrush is a hoof disease which comes from a fungus. It's liable to start up in a dirty foot in damp weather, and when you clean the foot it has a dead mouse smell rather than just a manure or dirt smell. Don't wait for further symptoms but douse the clefts of the frog with Kopertox or whatever the vet recommends, once a day for three days—longer if the weather stays wet. If you let it go the frog gets soft and queer and the crack in the middle may run up the back of the heel, and the horse goes lame. It will clear right up with treatment, but some horses seem liable to have it come back again.

Lameness A horse's legs and feet are about his most vulnerable point. In the wild, running on soft grassland with no weight on his back he probably didn't often get into trouble, but running on hard roads, with shoes nailed to his feet, and a weight on his back, and making sudden stops and starts and sharp turns at the command of a rider, to say nothing of jumping, a small trouble soon becomes a big one. So if your horse shows any signs of lameness, don't ride him. Don't ride him at all.

How do you tell? You would think a lame horse would hang back, go on three legs like a dog, or otherwise tell you plainly his feet hurt. He's not that sensible, unfortunately, and being big-hearted and liking to go, he will go cantering along when you ask him to just as if nothing hurt him—when all the time his feet are killing him. So, when he's standing still, be suspicious if his weight isn't evenly on the two front feet. (With the back feet this doesn't count; horses often stand with one back foot cocked and it doesn't mean a thing—unless perhaps it's always the same back foot.) But if he keeps the weight off one front foot, it means either present trouble or an old injury. If he has one front foot in advance of the other, that's the one that probably hurts him.

At a walk you can't tell too much, unless he's very lame. Trot

him on a smooth surface, even a little way on the hard road (which in general I hope you avoid doing). Sit to the trot or stand in your stirrups so your posting doesn't make him uneven. Listen hard to the hoof beats; if you hear an unevenness he has trouble somewhere. Watch his head or get a friend to watch for you. If it bobs down at all the foot that hurt just left the ground. At a normal trot the head is steady. Look at his footprints—he may not be picking up one of his feet because something hurts him in his leg. If any of these things show up, don't ride, and send for the vet. With luck, a week or two of rest and some simple treatment, a slight ailment will cure itself. Let it get worse, and become chronic, like a bad tendon, and you have a horse with a permanent weakness.

A hoof or lower leg that's hotter to the touch than the other three can mean trouble, perhaps a strain, perhaps an infection. Be on the watch.

Apart from an injury, the chief serious cause of lameness is trouble in the bones of the foot and ankle. Sidebone and ringbone are names for an extra growth of bone there, like the knobby knuckles of a person with arthritis in his hands—and I expect they feel about the same. An opposite kind of trouble is navicular disease, in which one of the little bones inside the foot gradually breaks down.

Most old horses, like most old people, have more or less trouble with arthritislike difficulties. If they don't mind it, you don't have to worry. I've known horses that had a number of good years with the horse version of aspirin to keep them comfortable. On the other hand, if a horse is too miserable to move, and can't be helped he shouldn't be kept to suffer just because you're soft-hearted.

There are some rather radical treatments for sidebone and ring-bone, which sometimes work. Navicular disease is so far incurable. You can make an effort at prevention by feeding the horse the best diet you can, and making sure his vitamin and mineral supplements are what they should be—but this is the sort of thing that develops over a lifetime.

Founder (*Laminitis*) Founder is a disease which causes a com-

This pony is having his feet soaked to help him recover from founder.

plete upset of the horse's system, but the most obvious symptom is the feet, so that is why I mention it with foot troubles. In acute founder, all the horse's feet hurt him just dreadfully and he may lie down, or stand all bunched together and be unwilling to take a step. His hooves are hot. What has happened is that the soft tissues between the hard parts of the hoof have swelled, and since the bone doesn't give the pressure is very painful.

A less acute attack may be in the front feet chiefly, so the horse stands with them stuck out in front of him, or the only thing you may notice is that he's walking oddly. The two front feet are hot, however, which warns you to send for the vet.

Horses can get founder from a great number of things, but the most likely one to hit the ordinary backyard rider is having the animal get into the grain bin. It can also occur if you bring a very hot horse back from a ride and just let him stand, or let him drink too much cold water while hot. Overwork can also cause it. Sometimes ponies get it when turned out to grass. Mares can get it just after foaling if their diet is too rich or an infection of the uterus develops. Of the two horses I know who got free in the barn at night and stuffed themselves, one got founder (but made a good recovery) and one didn't get sick at all. Happily, prompt early treatment for this is very effective, which is encouraging, because a really bad case ruins a horse's feet for good.

Colic Colic is a chief horse killer and it can happen to anyone, even the most pampered horses in the best stables. But you can try to avoid it by keeping your horse on a sensible regimen, with good clean food and reasonable exercise. Colic is a term for various kinds of horse stomach ache. All of a sudden one day your horse doesn't finish his supper, or he lies down when you don't expect him to and if you get him up he lies down again, or he sweats or shivers, or kicks or bites at his stomach and it isn't because of a fly. Don't wait. Phone the vet.

Until the vet can get there, stay with the horse. Try to keep him from lying down and with this in mind walk him gently. If he does go down and you can't get him up, try to keep him from

going over on his back and struggling, as this is what can give him a twist of his intestines and kill him. Prop a bale of hay at his back so he can't roll over, or gunny sacks stuffed with hay. Try and get him up.

Whether you do anything else depends on how available your vet is. If you know you're miles from help, you might arrange ahead of time with your vet for you to have some medicine on hand, just in case, and teach you to pour it in small amounts into the back of his mouth without choking him. The medicine will probably contain a sedative to ease the pain and a laxative to move the trouble along. When the vet comes, he can inject a quick-acting medicine into a vein.

Spasmodic colic, in which the intestine gets out of order and too much gas forms, usually cures right up. If the intestine is really blocked, the horse is in trouble because the gas can't move along— that takes skilled treatment and luck.

Cheer up. Most cases of colic are OK next day. And then you can rack your brains to figure out where you slipped up. Sometimes it's just a change in the weather, sometimes your horse was extra vulnerable to it, sometimes you were careless about water, or clean feed, or too many apples, or a chill after exercise. Spoiled hay or feed is a big offender. So are worms.

Shipping fever This section should really be headed "Respiratory Diseases," but we will hope that the only time your horse gets the horse version of the common cold or flu is when he's being shipped to you—and it's so common for horses to catch some kind of virus at that time that it's received the name "shipping fever."

Like the common cold, it usually clears up by itself after running its course. Like the common cold, it can go into pneumonia and other unpleasant things but isn't likely to. Don't assume you can tell if it's "just a cold" or something more serious. Let the vet check him to begin with and tell you what to expect and what to watch out for.

The horse feels poorly and hangs his head. His nose may run. He may cough. He doesn't eat much.

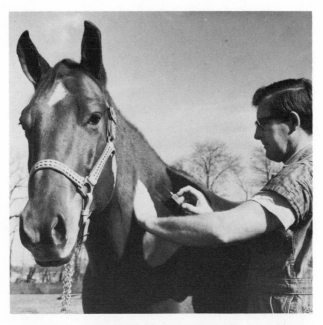

Most horses are calm about shots (top). Medication for cuts is not only antiseptic, but keeps flies away (bottom).

You want to take his temperature in order to keep track of how he's doing. This is easily done with an ordinary rectal (human) thermometer. Put a little vaseline on the end and put it about half its length into the horse's rectum. Keep a good hold on your half so that when he tucks that strong tail down in his surprise he won't push the thermometer all the way in. A minute is long enough. Normal for horses is 100½° to 101½°.

You want to make sure his bowels keep moving. The vet will probably say to feed him bran mash. This is simply hot cereal for horses. It's a mild laxative and also easy to eat with a sore throat. You get the bran at the feed store. Here's one way to make it: put six quarts of bran in a bucket, add hot water until it's good and wet but not watery, allow to cool to a comfortable temperature, and feed. The horse will probably say he likes it.

If the vet wants you to feed pellets, he may say to pour warm water on these too to make a sort of mash that's easier to eat and more inviting. Besides, a horse with a fever needs the extra water.

Let him walk around in his paddock if the weather is nice, but don't let him get too hot or too cold. Don't ride him while he feels poorly, and when he's better but still has a cough ride him gently and don't get him sweated up. Keep a blanket or cooler on him if the weather is chilly, and make extra sure he doesn't have to stand in a draft and that his stall is bedded good and deep—and clean. You will have to fuss over him for a bit, but you will probably be rewarded in a week or ten days with a healthy horse.

Chances are if the horse is shipped in a public conveyance, rail or motor, or kept in a barn where there are transients, he will pick up a cold. The preventive shots work well enough for you to consider having the horse protected—if you have any control over what happens to him before you get him.

Skin diseases A horse can get ringworm just like a human, and unfortunately it's the same germ, so you can catch it from him and he from you. Be suspicious of any odd skin eruption in a circle shape. Horses can also get mange and various fungus skin troubles.

Always using your own clean brushes, and clean blanket, can help avoid that. Treat any of these diseases promptly or they will spread and the horse will be miserable.

Horses sometimes break out in a rash in summer as if their feed was too rich for them, or may even get hives. A change or reduction of feed usually takes care of that.

Cuts and scratches You take care of a cut or scratch on a horse first with a mild soap and water, then an antiseptic. This should be something which will also keep off flies. Your grain store or saddler's may sell one of the new antibiotic sprays which are satisfactory for minor injuries. If the cut looks as if it will have to be stitched or otherwise needs the vet's help, don't do anything more than wash it. Never apply a thick medicine which will make treatment by the vet more difficult.

First aid for a horse's wound is basically the same as for a person's. A tight compression bandage will stop bleeding on a leg— and must not be left on without being loosened every ten minutes. If the horse has a deep wound or a puncture wound, he needs a tetanus shot. Don't overlook the fact that the bottom of his hoof is not as hard as the sides and may be pierced by a nail or broken bottle.

Call the vet early This is your first horse and you don't really know what to expect yet. Don't try to save money on the vet's bills—for the first year or two anyway. If something strikes you as not right, speak up. The vet would certainly rather you did, even if he's busy.

The only times we got in trouble with our first horse were when we were puzzled and decided to wait and see. It takes a while to learn all this, and the poor horse pays for your mistakes.

10. Tying the Horse (Simple Restraints)

Western horses are often trained to stand if their reins are dropped on the ground. This is accomplished by fastening the young horse to something really immovable, and then gradually conning him into obeying the signal of dropped reins. But most horses should be tied up one time or another and it's good to learn to do it safely.

Try to avoid tying up a horse by the reins. If you can plan ahead when you start your ride, carry a halter and rope. This may someday save you a broken bridle, because if a horse is frightened and really pulls back on a bridle he will break it and run off. Also if the reins are fastened to the bit he can jerk his mouth and frighten and hurt himself that way. If you must use the reins, undo them from the bit and fasten them to the noseband, or around the neck.

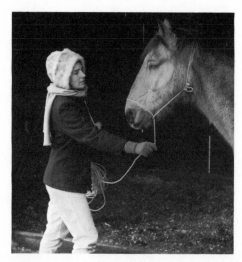

*You can make an emergency halter of clothesline if you have
nothing better at hand.*

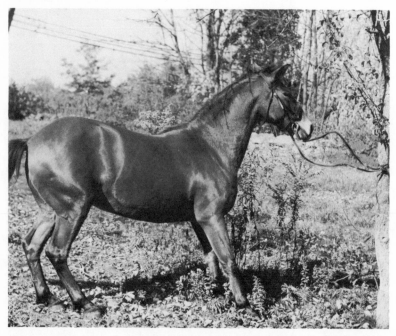

*A mistake to avoid: this horse was tied by the reins and broke
her bridle in three places when she was startled and pulled
back.*

What do you fasten the horse to? Either tie him to a branch of a tree which gives and won't break, or to a good strong tree or fence post. If you tie him to a fence rail and he's frightened and pulls the fence rail loose, he's then being pursued by a monster in the shape of a fence rail and anything can happen.

When tying him with a rope out on the trail, say, or when you have gone visiting, tie the rope at head level or higher. The best thing is to make the rope so short he can't get his head to the ground to graze, but if you want him to be able to nibble a bit, make the rope no longer than just lets him get his head to the ground—no slack lying on the ground for him to get his leg over. Getting his leg over the rope is the usual way of getting in trouble when tied up.

Try not to leave a tied horse alone unless you're sure he's smart about ropes. A lot of them are clumsy about them. Make the knot for quick release.

Practice the quick release knot and emergency halter knot on the next page. Ninety-nine times out of a hundred you won't need it and the hundredth it will be a godsend. Just picture to yourself 1000 pounds of hysterical horseflesh and a rope so taut you can neither undo the knot nor the snap fastener at the halter.

Your horse or pony may have the awkward habit of pulling back and breaking whatever he's tied up with. If the rope doesn't give, he will break the metal snap or pull out the screw-eye or whatever. With this customer, use a halter that's good and strong over the back of the head, new half-inch manila rope, and don't trust any ordinary snaps or screw-eyes. Fasten him to a hefty tree, or a good solid post. After a few tries he may be less eager to pull back. Use the horse knot and have an adequate knife available too, in case you have to cut the rope—he may get into a fight with it and throw himself and be unable to get up.

Someday you may have the problem of catching a strange loose horse. If he is wearing a halter and will let you walk up to him, that is easy. If he is leery of you, try picking some grass and hold it out invitingly. Then if he comes to eat it, reach *slowly* for that

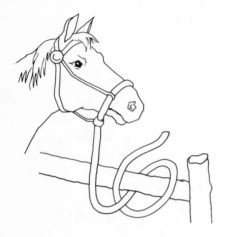

Quick Release Knot

If you always use this knot to tie your horse, you will avoid some nasty situations.

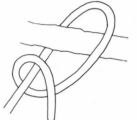

1. *under*

2. *over*

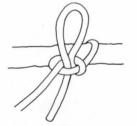

3. *loop up through*

4. *tighten*

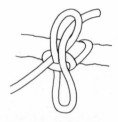

5. *For extra safety, put tail through loop*

Emergency Halter

This will work to lead a horse but not to tie him up.

Fasten your rope around the top of his neck in a way that can't possibly tighten and choke him. Use a bowline if you know how—or this simple pair of half hitches.

1. *Put one simple knot (half hitch) in your rope two or three feet from the end, depending on how thick the horse's neck is at the top. This will keep your second knot from slipping up.*

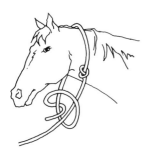

2. *Put the rope around the top of the neck.*

3. *Bring the short end around the long part of the rope—below the first knot——and tie your second knot. (Check that you tied it in the right place so it can't pull tight around the neck.)*

4. *Make your loop.*
5. *Slip it over the nose.*

A loop over the nose gives extra control.

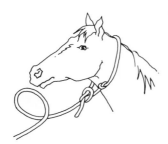

6. *Make the rope snug where the noseband would go, about one fingerwidth above corner of mouth.*

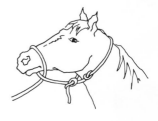

You can lead a quiet horse like this.

halter; if you grab, he can jump away even faster. If he just eyes you with suspicion from a distance, try to coax him with some feed in a bucket; shake the bucket so the feed rattles and gets his attention.

If he is wearing no halter, you have to have a rope. With a short rope, you can tie a non-slip loop around the top of his neck and he may be willing to be led. With a longer rope you can improvise an emergency halter like that shown on the previous page.

From this you can see that if you know you are going out to catch a horse you start with a bucket, some grain, a rope, and a spare halter.

You may wish to put out a horse in some grazing where there's no fence. If the district favors it, you can use hobbles to keep him from straying too far. But if there's street traffic near, or other dangers, you have to use a stake and rope. This is a risk. The stake must be put in firmly, it must be short, and stubby—there's a metal kind that just has a rounded eye at the top. Don't think I exaggerate—I had a friend whose horse killed himself by getting tangled in his rope and falling onto the stake.

The other risk is the rope. If the rope gets caught at the back of the horse's foot, he isn't made so that he can bend the foot up away from the rope and get free. He just goes on fighting the rope and it cuts deeper and deeper. (This is awful if it's wire, of course.) You'll see such a scar on many a horse, so try not to let it happen to yours. If you feel you must stake him out, stay with him quite a time at first and watch how he handles his feet and if he seems clever about staying out of the rope's way. If he's clumsy and you can't stay with him, the grazing isn't worth it.

A possible safety measure is to put an eight-foot length of hose or pipe over the rope at the horse's end. A knot tied at each end of the hose piece will keep it from slipping. This will keep the horse out of trouble at least with that eight feet of rope, and that's usually what gets around his feet as he grazes.

You may want to tie up a horse in his stall. This again is a

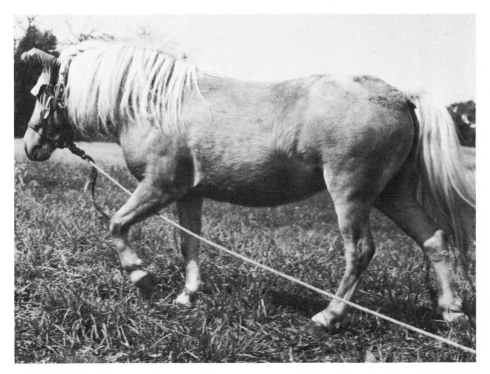

Hobbles come in a variety of materials, including leather with buckles, and rawhide. Use them only below the ankle, never above it.
Avoid this: a rope-burn can be serious.

case of tying the rope high enough and short enough so he can't get his leg over it. If you want him to be able to lie down freely while still tied up, you can rig a pulley arrangement with enough of a weight on the other end of the tie rope so that the rope leads up from his chin at all times but still gives him freedom to get up and down. The two wheels the rope runs over need to be well constructed and the rope must run freely or you are worse off than you were before.

Sometimes you may have to restrain your horse a bit more firmly, for instance, if the vet needs to do something he really objects to. One way to keep him quieter is to hold one front foot up close to the elbow. The horse can hop around on three legs but not so freely.

Another useful device is the twitch—a loop of rope with a handle. You take a piece of his upper lip and tighten the rope around it just enough so he pays attention to that and not to what the vet is doing. (Some people use a twitch on the tongue or ear but that is too dangerous.) A horse who has had a really bad experience with a twitch may go crackers if he sees you coming with one, so stay alert. Properly used, however, it's a big help.

A similar restraint is to put the chain of the lead shank along the gum of the upper teeth under the upper lip. Most horses will mind pretty well in such a situation.

There's sometimes an odd horse for whom tranquilizers or sedatives act as stimulants, but usually your vet can use a tranquilizer or even a general anesthetic if he really needs the horse quiet.

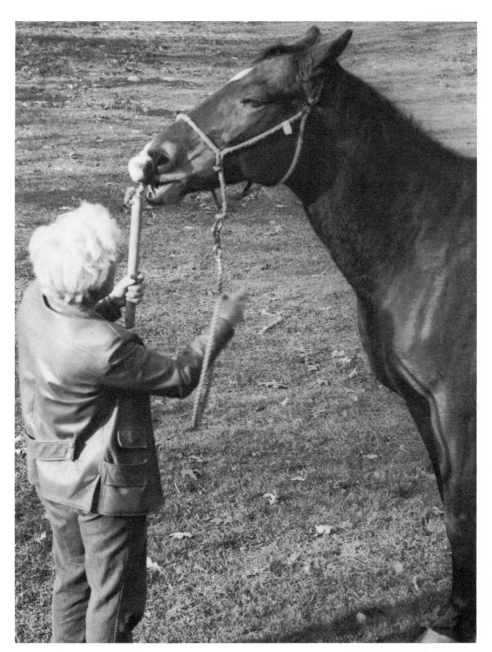

A twitch on the upper lip is a humane form of restraint if used with care.

It will help horses get used to the trailer if it is left in their paddock, but be sure that it is properly blocked fore and aft so it can neither tip nor roll.

11. Trailering your Horse

There is no magic formula for instant trailering, and every professional has been through some hair-raising experiences. When you take on your first horse, find out if he will load easily, if he travels quietly, if he is willing to travel alone or must have a buddy, if he will get upset if you take the buddy out of the trailer. Then you can make your plans accordingly.

Here are some points you have to cover before you can even begin to haul a loaded trailer with any degree of safety.

First, the mechanics. Your trailer and your hauling vehicle should match, the hitch must be equal to a heavy job with a live load, the lights and brakes must work right. Some trailer brakes can be operated independently of the car brakes, and some are syn-

chronized. Whichever way you have it, make sure it is working correctly. This is particularly important if you are coming down an incline and the load starts to weave. With proper brakes you can straighten right out. Otherwise the only way to avoid jackknifing is to race faster than the trailer down hill in order to straighten out. Did I say hair-raising?

Check that the mats or floor covering of the trailer give a good grip for the horse's feet and cannot be pawed up easily. Straw or hay on the floor will help. Plain old dirt will provide traction on a wood floor.

Double check that the floor is solid. Droppings and urine can easily rot the wood floor especially at the rear. Rust can weaken the frame underneath. Then one pile-driver hoof can punch a hole, with dire results. If there is any doubt in your mind, add a layer of half-inch waterproof plywood.

You will have to drive as if you were carrying your grand-mother's best china piled up on the back seat. Easy stops, easy starts, easy curves. Anticipate changes in speed or direction. Your horse has to work continuously to keep his balance back there, even if he is experienced in trailers and takes it all calmly. If he gets too shook up, he may throw himself or get wedged into some impossible situation from which you need blowtorches and the fire department to extricate him. He can start climbing the walls, surging forward and back, or rearing and kicking, and believe me, a frantic horse can take any trailer to pieces and kill himself in the process.

In addition to driving like an angel, prepare things to keep your horse's mind calm. See that he has no food for twelve to twenty-four hours before moving. Then provide a haynet full of hay in the trailer and keep it full of hay, and he will think a lot more about eating than about fussing.

A lot of horses will travel calmly with another horse beside them, but get hysterical alone, so a calm friendly nursemaid horse may be worth arranging for.

Always plan to have a helper with you until you are fully ex-perienced with a particular horse.

Loading can be all kinds of a problem. Be prepared to use

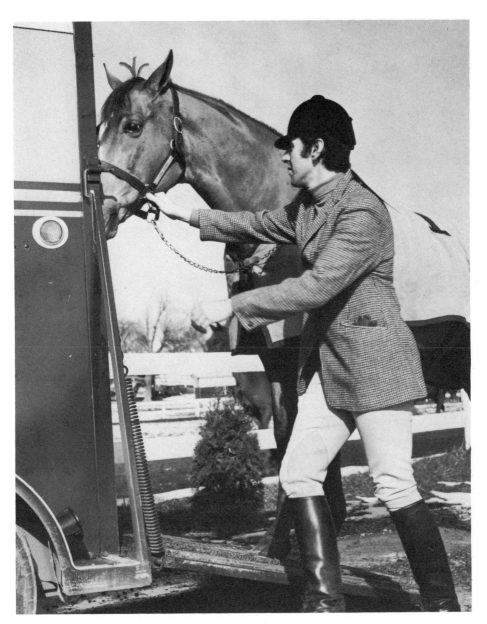

You can teach your horse to walk into the trailer by himself while you stand by to hook the tail gate chain.

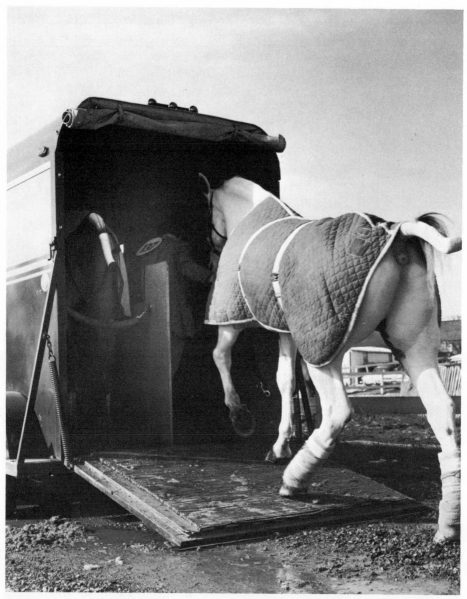

Before shipping a horse in a trailer, you should bandage his legs and tail.

coaxing and patience. If you can convince yourself that of course this horse is going to load when you tell him to, it will help convince him. So first off, try leading him straight on with some firm cheering words when he hesitates. The dropped tailgate sounds hollow as he steps on it and he will be suspicious. If he puts his head low and blows and sniffs, eyes and ears alert to investigate this strange thing, he is showing anxiety; this is your cue to be firm and encouraging and not to rush him. If his ears are backwards and his head up, you can use a commanding voice, and your helper can apply a crop or rope's end at his rear to show you really mean it.

If he won't lead right on, he may follow you on for grain or carrots. If he will put one foot on the tailgate, tell him he's good and reward him. Then ask for the next foot. Reward. Then ask for the rest.

Don't waste your strength if he is determined to pull back away from the trailer. Go with him, lead him in a circle, and bring him round to the trailer again.

Above all, keep things calm. If you have to lead him up to that trailer seventeen times, then do it, and maybe the eighteenth he'll give up and go right in. Avoid cracking whips, shouting, or beating; if you frighten or hurt him he's just doubly determined to avoid entering that terrifying box that is causing him all that trouble.

If you have two helpers, you can try adding some muscle power from the rear. Place a thick rope around his rump and have the helpers pull forward while you lead. Or they can use a pole or 2 x 4 against his rump the same way. With a small and not too ambitious horse, they can practically boost him aboard.

Know when you are licked. If you, as a beginner, have to cope with a horse who kicks, or rears, or goes into a frenzy when confronted with a trailer, it is just not sensible to go on. Lead him or ride him to where he can stay until an experienced person can transport him for you.

In the trailer, first fasten the tail chain and put up the tail gate. Then tie him by his halter, fairly short, just so he can get

at his haynet easily. An occasional horse will fight to get his head free, so leave him enough slack so his rump comes against the back of the trailer, but not so much slack that he can get a leg over the rope. If he is traveling alone, put him on the lefthand side, to make up for the tilt of the road.

Try to have him back out slowly and carefully. Some horses rush backwards when released and damage themselves that way. Do it in this order: first one person unties his head and stands there holding the rope, then the other person lowers the tailgate, undoes the tail chain, and puts a steadying hand on the horse's hip so he won't fall off the edge of the tailgate coming out crooked.

For safety, he should have his legs wrapped to protect him against scrapes and stepping on himself, and his tail wrapped to keep him from rubbing off the hairs, but this has to be done right or not at all. Try to get an experienced friend to do this for you or show you how. If you can't learn ahead of time, the risk of your damaging his legs is probably as great as the risk of leaving them unwrapped, so skip it. Be aware, however, that you are taking a real risk.

Once you have him home, take six months to make a perfect trailering horse. Let him have the trailer in his paddock. Let him eat in it and drink in it and get thoroughly used to it. Let him take hundred-yard trips in it that net him something delicious to eat. When you practice leading in, get him used to staying in and eating; if you practice leading in and out again right away, you may teach him to pop out every time you think you have him safely in.

You can get him so he thinks trailers are a good thing, and what a triumph that is, to say nothing of the convenience. I have a friend whose racing ponies look forward to traveling so much that when the trailer appears all three ponies try to crowd into the space for two as soon as he opens the back.

12. How Not to Buy the Horse You Don't Want

Since this is your first horse, and you didn't grow up around horses or you wouldn't need this book, you are the sucker and only too liable to find out how the term "horse-trading" got into the language.

The best way not to buy the wrong horse is not to buy one. Borrow one. Take care of a neighboring one for the privilege of riding it. Or take on a camp horse for the fall, winter, and spring, again for merely the cost of its feed and care. A few riding camps have year-round use for their horses, but most of them farm them out to people for the winter. The camp owners run the risk of having inexperienced people taking care of their horses. On the other hand, a good camp horse is a reasonably calm, peaceable animal, past his first youth, and his bad habits are not likely to

be very dangerous—he will have some, however, because every horse does.

If you must buy, take your time and go slow. Most people who are selling a nice horse which is a member of the family, so to speak, want to find him a good home, so they do not start by advertising and seeing a lot of strangers. They pass the word around among local riding instructors, livery stables, the grain merchant, the saddler, the horseshoer. This is where to put your ear to the ground. Be realistic about what you want. If your riding ability is not very great, settle for a "good beginner's horse." Of course if you are further along, with your eye on certain kinds of showing or jumping, you know what you want and you already have your contacts. But work up to that gorgeous purebred slowly. Just as a matter of dollars and cents, do you want to learn how to take care of horses on several thousand dollars' worth of nag? To say nothing of the fact that most purebreds are more spirited and it's a lot easier to start on something milder.

Watch the ads in local papers. If an ad sounds inviting, go and look. You will soon discover that an outfit which advertises a mixed group of this and that along with a couple of ponies (with tack), is likely to be a commercial venture with unfriendly, not very healthy looking animals. The single horse owned by a youngster off to college, or moving away, is likely to be a better bet. Furthermore, people like that are not likely to sell you an animal they think will be too much for you, since they know it will cause grief all around.

You will soon find that every horse is an individual. And how! Some you like and some you just don't take to. If you really like one, go back and see him again when he doesn't have his best foot forward. Try him out under the owner's eye.

Finally you get to the point of thinking this might be the horse for you. Stop right here and have the horse "vetted." Find out the best-respected horse doctor of the district, or a good one who is not also the seller's vet, and have him check the animal. This is standard practice, and does not imply that you doubt the owner's word or anything. You will then know for sure that the horse hears

The first thing to determine about your prospective horse is whether he is friendly.

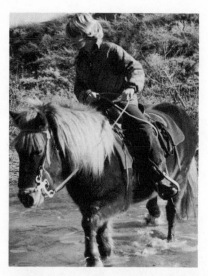

Will he cross water (top)? The quarter horse is strong and willing (below).

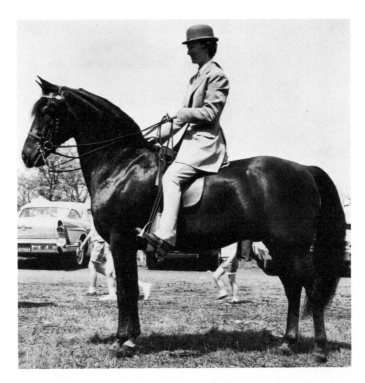

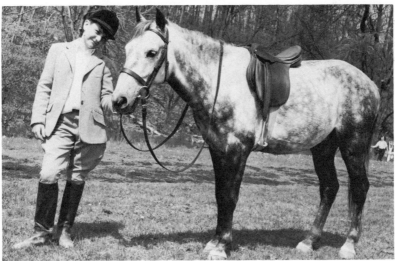

*The Morgan is a native American breed (top). With care, you
will find the perfect horse for you (bottom).*

and sees properly, his heart and lungs are OK, his legs and feet are in good shape, he doesn't have any chronic diseases—in a word, he's sound. Also, it will give a closer idea of his age.

Sometimes owners don't know, and sometimes they don't say.

Do not, repeat *not*, assume that you can look at a horse and tell he's all right. Even professionals get fooled, and the tricks that can be resorted to, to obscure this little problem or that, are beyond counting.

Then, if at all possible, arrange to try out the horse, either at his home or your home, perhaps for a week or two. You should have the privilege of returning him if he is in good shape. Have it settled whose liability it is if he drops dead two days after you take him on trial.

Among other things you want to find out during the trial period:
1. His temperament.
 Is he calm and friendly, or cross and mean?
 How does he respond to being startled or frightened? Does he really lose his head and try to bolt, or is he fairly sensible in his response?
 How does he respond to discipline? Does he fight back, or does he give in quickly?

2. His behavior with other horses.
 Does he bite or kick in a field with other horses, or on the trail?
 Is he quiet when ridden in company or does he get all steamed up?
 Will he go willingly away from other horses, or remain calm when others leave him?

3. Stable manners.
 Will he stay quietly in his stall, not chewing the wood or pawing up the floor, or weaving himself from side to side?
 Does he explode after being shut in for twenty-four hours?
 Does he pull back when tied?

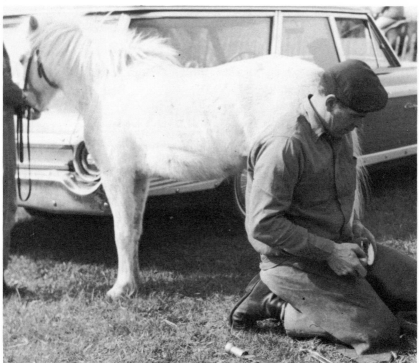

A short girl can bridle a tall horse (top). And a big man can shoe a small horse.

Will he let himself be caught when loose in a big field, at least with the help of tidbits?

Will he lead quietly?

4. Is he fun to ride?

Does he seem to enjoy the kind of riding you like to do?

5. How does he behave on the trail, in the ring, in jumping?

Will he cross water?

Will he lead willingly into a trailer, ride quietly, back out slowly and obediently?

If he's to jump, test his jumping both on the longe (if you have a skillful friend) and mounted (if you're good enough).

Some reasons to wash out a prospect:

1. If he's impossible to stable happily.
2. If he charges you in the paddock and frightens young riders.
3. If he rears when led or ridden.
4. If he tries deliberately to unseat a rider by swerving, scraping him off on a tree or under a low branch, ducking his head down suddenly, whirling about, rearing, bucking, or bolting.
5. If he gets hysterical when frightened. Distinguish between panic flight, which may take you into a dangerous situation, and the pleasure a strong horse takes in galloping across an open space despite his rider's protests. But don't take on a too-strong-minded horse if your riding isn't up to it.
6. If he kicks at people.
7. If he's uncontrollable when left alone by other horses during a ride.
8. If he is a chronic shyer.

Professionals cope with all these problems, and more, but there's no reason for you to have them with your first horse, when you can find a pleasant-tempered one with just a bit more looking.

Horse or pony? Those cute little shaggy fellows may be less scary for very small children. On the other hand, they can be awfully stubborn and are more likely to do what they please, while a big old friendly horse will take better care of the rider. Ponies

Some ponies are small enough to pack in the family car, but a trailer is much safer.

are cheaper to feed, easier to house, hardier in general. Also they are easier to take with you for the summer, since they can even travel in a Volkswagen bus. They will be outgrown, which is a sad thing to come to. But the perfect beginner's horse is likely to be outgrown too, when a young rider is ready for something more challenging. A large pony or small horse, somewhere around 12 to 14.2 hands, is likely to have horse temperament (not so stubborn) and horse gaits (smoother to ride) with a good deal of pony ruggedness and easy keeping. A hand is 4 inches, measured from the highest point of the withers, behind where the neck joins the body, to the ground. Welsh and Connemara blood is distinguished for gentleness and common sense, if you stay away from the fancy show strains. A good Western horse is great and likely to be around 15 hands, and Quarter horses and Appaloosas are bred for good sense and good using qualities. Horses bigger than 15 hands require more food, and you may have a problem if a young rider cannot reach up high enough to saddle and bridle them conveniently. Of course, with the right temperament of horse, the child can stand on a box and it works out all right.

Whatever you do, don't buy your first horse from "The Auction." This is a sale barn where regular sales of miscellaneous animals are held. It's strictly "buyer beware." People put their horses in the auction when they can't sell them on a personal basis, because of some unsoundness or serious bad habit.

There are good and bad horse dealers just as there are good and bad used car outfits. Conscientious dealers exist (not very frequently) who will try to help you find a horse that's really right for you. However, if you're inexperienced, the two of you don't speak the same language. Try to have an expert friend help you here.

Incidentally, buy a horse in good condition. That appealing thin one may touch your motherly instincts, but he may be so fierce that the only way the previous owner could handle him was to keep him thin, or he may be one of those nuisance animals who just won't stay in condition.

If you don't intend to jump, but just want to do mild trail

A hand is four inches, and a horse's height is measured in hands from the withers to the ground.

Jumping takes a lot of training for both you and the horse (top). Barrel racing requires perfect co-ordination between the horse and rider (bottom).

or ring work, a "limited horse" may be fine for you. This is an animal who is getting on, or who has been jumped so much that his legs are not up to the strain of jumping any more, but he can stay in perfectly good shape with reasonable work on the flat. He would come cheaper, and there would be a little more risk of his eventually breaking down, but there are a lot of nice horses in this category.

Another reasonable "bargain" is the horse who has mild heaves. Heaves is similar to human hay fever or asthma, and usually the horse is allergic to hay and straw and can't have them to eat or even in the barn with him. But keep hay and straw away from him, feed him pellets and bed him on shavings and he's fine. He needs room to graze, however. Many a horse who always gives a cough or two when he starts to work has a touch of heaves. Avoid one who has such a severe case that his coughing impairs his ability to work.

Rule out any other unsoundness. A "touch of" founder or laminitis, blindness in one eye, deafness, or any other in the catalogue of horse handicaps, can cause you more trouble than they are worth.

The gift horse is a problem. He may be a package from heaven. But he may equally well be a way out for an owner who has an unsound horse he can't sell and hasn't the heart to have put down. Here you could say, since the horse is probably old, that you would like the vet to check him over to see if he has a few good years yet. It may be a little embarrassing, but it will be a lot more embarrassing to take on somebody's old darling and then have to have it put down yourself.

Why not a young horse to bring up and train? Training a horse may not be much more difficult than training a puppy, but you have to take the horse a lot further, and the results are a lot more important to the owner's health and happiness. It's very difficult to train up a young pony without making mistakes that will last his whole life—particularly if he's a "first horse." And then he's likely to be an unsafe ride. Further, a foal eats almost as much as a grown animal and must have constant attention to his diet, his vitamins and minerals, and his worming program, just for a

start, or he will not develop properly and will break down at an early age. And since a pony or horse should not be driven seriously until around two and a half or ridden until three (depending on the age when the bones in his legs are fully formed) there's a long wait before a young animal can be used, and even after you can ride him, he's still young and giddy and not too reliable.

Don't let anyone saddle you with a stallion, that is, an entire unaltered male. Some stallions are mild and well-behaved individuals, so long as they are handled by the right person. But a stallion has to have that top-dog viewpoint—that's what he's about. So rule them right out. They need expert handling.

As between mares and geldings, the individual's manners and temperament count most. Geldings are more even-tempered as a rule. Mares tend to be more sensitive, and when they are in heat they are sometimes unpredictable. Either one, however, can make a good safe beginner's horse.

13. Your Very Own Horse

The day is damp and overcast and cool, and everything green looks extra green. You go for a ride in the woods, and the horse moves almost noiselessly on the soft trail. Baby pheasants and baby rabbits don't even bother to be afraid. As you go quietly along you spot where the bluebirds must be nesting and listen to all the woodland sounds. The leather of the saddle gives an occasional pleasant creak. You know you both are enjoying all the woodland smells and the feel of the soft air.

*

You walk down to the mailbox and pass your paddock gate. Standing in the shade, your horse pricks up his ears and considers what you're about. By the time you come back, he is waiting for you and whinnies just enough to say Howdy. He wants a pat and

The pleasure of riding—alone or with company—is one of the joys of life.

a bit of conversation about the weather. If you're having an apple, he wants some of that too.

⚬

A snapping glorious brilliant day in fall. What a day to go riding! The air tastes so great you could drink it. The horse feels like stamping the hills away beneath his feet and so do you. Riding a rented horse was never like this, because you and your horse are old friends and can almost think together.

⚬

Dark night. Was that a noise in the paddock? Maybe you should just slip down and see. The night is big and black and awfully still. You find his gate and say his name real quiet. Where is he anyway? A couple of soft thuds arrive where you are and a velvet nose checks to make sure that it's you. The horse blows gently at you down his nose and ruffles his nostrils in a noiseless whicker. You give him a little more hay and he munches quietly in the dark. I don't know any more soothing sound than your own horse contentedly munching. At least all's right with his world.

⚬

A horse show day and you are showing your horse. How extra specially gorgeous he looks today with a coat like satin and everything trimmed and polished. What excitement in the air and in every snap of the pennants and crackle of the loudspeaker. Up and down dash all the handsome horses and their riders, everyone on his mettle. Is there a thrill to match your first ribbon? Great old horse, didn't he do you proud!

⚬

Here's wishing you all these pleasures and many more—with your First Horse.

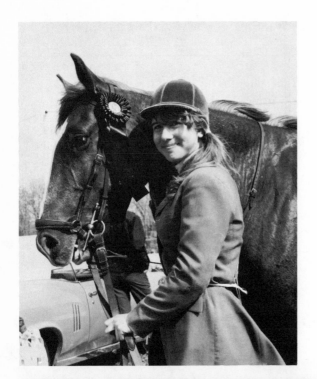

*With hard work and patience, you will experience the excitement
of show day and your first ribbon.*

For Your Bookshelf

If you are going to have just one reference book on horses:

THE HORSE: Judging, Breeding, Feeding, Management, Selling, by Donald J. Kays. (Rev. ed. Barnes, 1969.)

Other first rate books for care and special problems:

HORSEMAN'S ENCYCLOPEDIA, by Margaret Cabell Self. (Rev. ed. Barnes, 1963.) This author has written many books full of useful information on riding (forward seat), care, and history of the horse.

PONY CARE, by Jean Slaughter. (Knopf, 1961.)

THE BACK-YARD HORSE by Peggy J. Pittenger. (Barnes, 1964.) Great for the shoestring owner. If you think of breeding, read THE BACK-YARD FOAL.

For saddle seat riders:

SADDLE SEAT EQUITATION, by Helen K. Crabtree. (Doubleday, 1970.)

For forward seat:

COMMON SENSE HORSEMANSHIP, by Vladimir S. Littauer. (Van Nostrand, 1951.) The leading U.S. authority. You won't want to miss any of his books on riding and training.

TRAINING HUNTERS, JUMPERS AND HACKS, by Harry D. Chamberlin. (2nd ed. Van Nostrand, 1969.) Still a basic book, making use of the best of U.S. cavalry wisdom.

SCHOOL FOR YOUNG RIDERS, by Jane Marshall Dillon. (Van Nostrand, 1958.) A Littauer pupil writes for young people.

RIDING AND JUMPING, by William Steinkraus. (New ed. Doubleday, 1969.) Insight and good sense from a top U.S. Olympic rider.

For western riding:

SADDLE UP! The Farm Journal Book of Western Horsemanship. (Lippincott, 1970.)

BREAKING AND TRAINING THE STOCK HORSE, by Charles O. Williamson. (Rev. ed. Williamson School, 1965.)

BEGINNING WESTERN HORSEMANSHIP, by Dick Spencer. (Western Horseman, 1959.) They have a series of useful paperbacks on riding and care.

And just for fun:

LIGHT HORSEKEEPING, by Helen Mather. (Dutton, 1970.)

THELWELL'S HORSE BOX: Containing Angels on Horseback, Thelwell Country, A Leg at Each Corner, Riding Academy, by Norman Thelwell. (Dutton, 1971.)

THE WORLD OF DRESSAGE, by Neil ffrench Blake. (Doubleday, 1967.) Gorgeous pictures, see also WORLD OF SHOW JUMPING and PONY CLUB WORLD.

MY DANCING WHITE HORSES by Alois Podhajsky. (Holt, 1965.) You'll also enjoy his own story MY HORSES, MY TEACHERS.

Index

About the Author

Ruth Hapgood was born in Kentucky, and thereby came naturally to a love of horses. An early riding enthusiast, her book is based on the more recent but down-to-earth experience of learning how to take care of them.

Together with her two children, she converted some acres of countryside into rough and ready pasture and built a shelter from used lumber. Her "first horse" was a rugged part-Morgan of ripe age and experience, enthusiasm for doing things his own way, and an equine sense of humor. Later, a fox-trotting western mare, a gorgeous if clownish Albino, a Connemara to be raised and schooled under saddle, and a true-blue buckskin were all cherished members of the family.

If there hadn't been a lively 4-H horse club in town, none of this would have happened. The children joined at once, and so very soon did their mother, who now heads the club and works with dozens of new horse owners every year.

"We can still remember—vividly—all the dumb things we did," says Mrs. Hapgood. "That's why I decided to write a book, because the experts know too much. They've forgotten the things a beginner gets stuck on and how helpless he feels. It's no use the expert saying to walk a hot horse until he is cool if you have no idea how to tell when he's hot or cool. Our horses taught us a lot, and so did our expert horse friends, and we've tried to put it down in a form that will really help the brand new horse owner. They sure need it!"

Mrs. Hapgood was born in the bluegrass, married in New York City, and currently is settled in New England where she combines home life with work as a writer and editor.

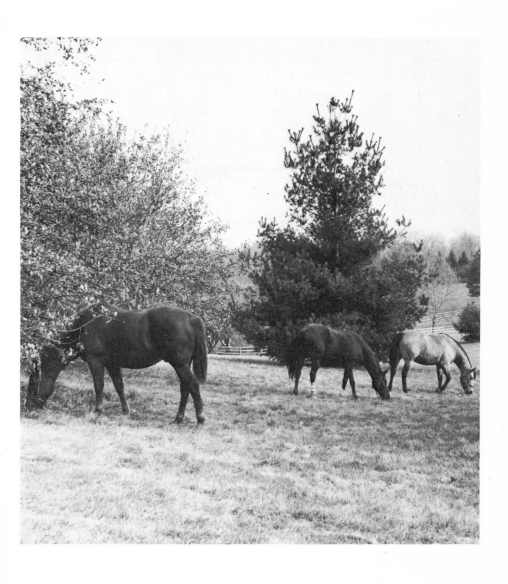